Peas, Pigs & Poetry

Peas, Pigs & Poetry

How a Gloucestershire Village School
Gained International Recognition

FIONA MEAD

AMBERLEY

First published 2011

Amberley Publishing
The Hill, Stroud
Gloucestershire, GL5 4EP

www.amberleybooks.com

Copyright © Fiona Mead 2011

British Library Cataloguing in Publication Data.
A catalogue record for this book is available from the British Library.

ISBN 978-1-4456-0455-8

Typeset in 10.5pt on 13.5pt Adobe Garamond Pro.
Typesetting and Origination by Amberley Publishing.
Printed in the UK.

Contents

Preface

I first came across the story of Mr Driver and Maisemore when I was helping out as a volunteer at Gloucestershire Archives. John Jurica, who was compiling the latest edition of the Victoria County History, asked me to look at the village school's logbooks to help in a very minor way with his research. Otherwise I would never have known about Maisemore, so I am very grateful to him and the friendly and supportive Archives staff.

Fascinated by the story I came across, I visited Maisemore and by chance met Val Chamberlayne, a lady of quite exceptional enthusiasm who had in next to no time rounded up former pupils, now in their 70s and 80s, who were interested in contributing memories. They were all absolutely delighted that someone was thinking of recording the achievements of Mr Driver for posterity. Everyone was so positive and encouraging that I decided to write this book, and I hope I have accurately recorded what I have been told. Any errors are mine and for those I apologise.

This story is a celebration of the success of determination, initiative and perseverance. It is proof that a cohesive community can become self-sufficient; it is proof that ordinary children can achieve extraordinary things; and it is proof that one individual with clarity of vision and boundless energy can provide the impetus to bring benefit and change to a whole community. It is the story of one school and one village, and shows what can be done with few resources and a lot of goodwill. But most of all, it is the story of one man who brought it all about.

Could it happen elsewhere? Times have changed, but some of the success could be replicated in modern communities. All that is needed is a catalyst for change, or shall we say – A Driver.

1

How It All Started

As the First World War raged overseas, a quiet revolution began in a peaceful village in Gloucestershire. No blood was spilt, no freedom was curtailed, but a gentle change in ideology permeated the community and worked as a force for good for generations. The village was Maisemore, just outside Gloucester, where there is a bridge over the River Severn. Most of the village lies along the main road, but there is no village green or obvious centre, and the church, the school and many of the houses were and still are dotted over quite a large area. Maisemore Park was known in the agricultural world as the home of the magnificent Maisemore herd of Aberdeen Angus cattle, but the village was otherwise unremarkable. The changes began gradually, but the ripples continued for many years – and the epicentre was the school.

In 1914, Maisemore Church of England School was typical of many rural schools in the country. The head teacher and the infants' teacher were both nearing retirement and their teaching methods dated from the Victorian era. Nevertheless, the children, with ages ranging from four to fourteen, were well cared for and happy, and the educational achievements, though not spectacular, were on the whole satisfactory. Yet within a few years the school had become a centre of excellence attracting a steady stream of visitors from throughout the UK and overseas to observe its pioneering academic work and its highly successful and innovative rural studies achievements. Indeed, in 1923 the Secretary of Gloucestershire Education Committee, Horace Household, wrote, with specific reference to rural studies, that 'Maisemore goes as near attaining an ideal as any school can go'. This change was down to one man, Mr Alfred E. Driver, who was appointed head teacher in 1915.

So, who was this man? And was there anything in his background to indicate his future success? Born in Stroud, Gloucestershire in 1891, Alfred Edgar Driver was only twenty-three when he arrived at Maisemore. He was the son of Rosa

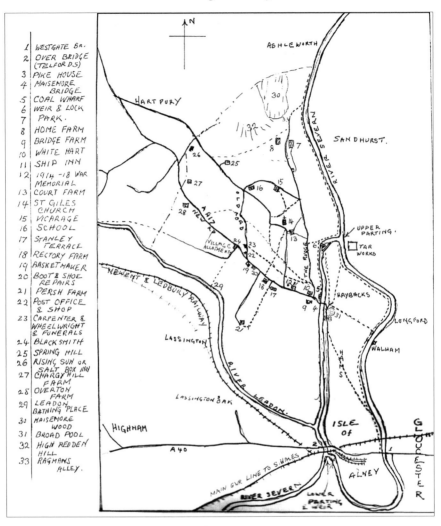

1 WESTGATE BR.
2 OVER BRIDGE (TELFORDS)
3 PIKE HOUSE
4 MAISEMORE BRIDGE
5 COAL WHARF
6 WEIR & LOCK
7 PARK.
8 HOME FARM
9 BRIDGE FARM
10 WHITE HART
11 SHIP INN
12 1914-18 WAR MEMORIAL
13 COURT FARM
14 ST GILES CHURCH
15 VICARAGE
16 SCHOOL
17 STANLEY TERRACE
18 RECTORY FARM
19 BASKETMAKER
20 BOOT & SHOE REPAIRS
21 PERSH FARM
22 POST OFFICE & SHOP
23 CARPENTER & WHEELWRIGHT & FUNERALS
24 BLACKSMITH
25 SPRING HILL
26 RISING SUN or SALT BOX INN
27 CHARGY HILL FARM
28 OVERTON FARM
29 LEADON BATHING PLACE
30 MAISEMORE WOOD
31 BROAD POOL
32 HIGH REDDEN HILL
33 RAGMANS ALLEY.

This sketch map of Maisemore, *c.* 1920, was drawn from memory by Gilbert Probert.

and William Driver, of Upper Mills, Stonehouse, where William was a domestic gardener. Therefore he was raised in a rural environment, but he was good at academic work. He and his two brothers, Wilfred and Francis, and sister Rhoda grew up in Upper Mills and attended Stonehouse Primary School. He went on to grammar school, where he was a successful scholar, and then trained as a teacher at Exeter Diocesan Training College.

He took up his first post at Tewkesbury Abbey Boys' School on 7 July 1913. This school was quite large for the area – around 140 pupils attended – and it was well run by the headmaster, Mr Joseph Legg, assisted by his wife and two other teachers. Mr Driver replaced an experienced teacher, Mr Dobson, who had been appointed to a headship in Devon. The pupils made good progress in the classroom and according to HM Inspectorate (HMI) reports, order and organisation were very good and the children responded intelligently to questions. They went on educational visits to the theatre and farther afield, for example to the British Museum in London. Outside the classroom, there was a garden and the boys had regular gardening lessons and visits from Gloucestershire's County Gardening Instructor, Mr Hollingworth. In February 1913, Mr Legg added care of poultry to the outdoor activities, and records show that in carpentry the boys made hen houses and also 'bee equipment'. All in all, it was a lively and successful school. In October 1914, an inspection report noted that the teaching was 'vigorous and on the whole successful in the upper classes where the boys are encouraged to think for themselves'. The emphasis on discipline, focused activity inside and outside the classroom, and particularly initiative, were all aspects very close to Mr Driver's heart. It was a good place to start his career.

By this time, most of Mr Driver's family had emigrated to Australia. First to go was his older brother, Wilfred, with wife and son, in December 1912, along with his younger brother, Francis, aged eighteen. Nine months later, Wilfred's sister, Rhoda, and her husband and son also emigrated to Sydney. Their father, William, had died in 1911, and given that all of the children, with the exception of Alfred, had now emigrated to Australia, it is not surprising that their mother, Rosa, decided to leave for Australia in September 1915. But they did not forget their British roots: although there was no conscription in Australia, Francis enlisted in the Anzacs in June 1916 and fought in the First World War.

Meanwhile, in February 1914 Alfred had married Gertrude Luker, the daughter of a butcher in Stroud. She had been brought up on a farm, but did not much like the rural life, and was therefore very happy to be marrying a teacher and moving to a town. In the nineteenth century and the early part of the twentieth, it was normal practice for the wife of a head teacher to play a part in the school, usually teaching the infants and giving sewing classes. Gertrude was in fact an expert needlewoman and would have been a competent teacher of sewing, but by 1914 there was more emphasis on certification, and throughout Mr Driver's subsequent career Mrs Driver took little part in school activities and was able to remain in

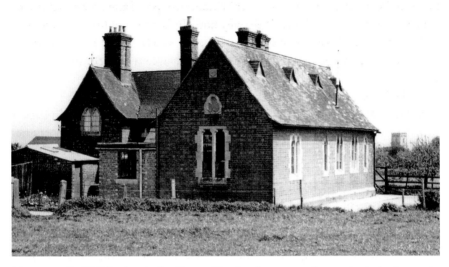

Maisemore C of E School and schoolhouse. The church tower can be seen in the background.

the background. In any event, 1914 was a year of sadness for the young couple as their new-born first son died shortly before Christmas. This may have had a bearing on their decision to leave Tewkesbury the following summer, or it could have been influenced by the fact that Mr Legg had resigned to take up his new post as headmaster of Mangotsfield School. Whatever the circumstances, Alfred Driver applied for the post at Maisemore Church of England School. He was duly appointed and with his young wife moved into the red brick schoolhouse attached to the two-room school on the outskirts of the village.

The New Arrival

1 September 1915 Alfred Edgar Driver commences as Head Teacher. Number of scholars present: 65. The work for the month cannot follow the schemes owing to the lack of stock which has now been ordered.

6 September 1915 Infants to leave at 3.30 so that master can devote attention to Standard I [six- to seven-year-olds]. Commenced Poultry class. Eight children have joined it.

These are the first two entries by Mr Driver in the logbook of Maisemore Church of England School, and with hindsight they give a good indication of the sort of man who had come to take over the running of the school. Lack of stock? He took

immediate action to remedy the situation. Preliminary assessment suggesting that Standard I was perhaps not up to scratch? He devoted special attention to help them. And as for the Poultry Club… Well, why not? (In fact the poultry at Tewkesbury Abbey School had had to be sold as Mr Legg's successor did not want them, but it is perhaps a step too far to imagine that Mr Driver brought the hens with him.)

While Mr Driver was at Tewkesbury, Maisemore C of E School was under the headship of Miss Leah Gardner, who had been in post for many years and was close to retirement. Although she was generally held to be a caring and conscientious teacher, it is clear from the logbook entries and Inspectorate reports that her teaching methods were old-fashioned, and she was very disorganised when it came to paperwork. She had been particularly criticised in 1913 for her cavalier attitude to the marking of the Attendance Registers. Despite this fact being on record, Maisemore School that same year won the School Attendance Shield (known as the Tibberton Shield, as it was originally presented by Mrs Price of Tibberton Court), and the managers proudly pointed out that there had never been a case of non-attendance (presumably they meant truancy) at the school under her charge. So her failure to submit new stock requisitions in the weeks before her retirement was probably to be expected and not ill-intentioned. It must, however, have been daunting for Mr Driver to arrive as head of a school and find there was little in the way of teaching material.

The reports of the 1914 inspections by HMI and Mr Household had also been very scathing about the teaching ability of the infants' teacher, Miss Emery, who retired shortly before Miss Gardner. They noted that the children's reading was very poor, and Mr Household doubted that the teacher would get better results whatever method she used. Counting was also poor: 'Most of the six-year-olds in the First class are prepared to say 2+2 makes anything but 4.' So Mr Driver was wise to take prompt action, as in 1915 his Standard I pupils were the infant pupils of 1914.

The vicar and school managers at Maisemore had been particularly keen to employ a master to replace Miss Gardner, but with the First World War in progress, many thousands of men, including teachers, had already volunteered. They were lucky to find Alfred Driver, who had not been accepted for the Army on account of his poor eyesight and a weak heart as a result of serious illness in childhood. Quiet and unassuming, with a strong Christian faith, he settled quickly into life in Maisemore.

If Maisemore was lucky to have Mr Driver, Mr Driver was equally lucky to have the support of a well-knit and caring community, even though its inhabitants were thinly spread over quite a wide area. They had been equally supportive of Miss Gardner. As the school was a Church school, it is to be expected that the local vicar would be closely involved and indeed when Mr Driver first arrived, the vicar, Reverend Charles Dighton, recorded in the logbook, 'This September is notable as the first time we have had a schoolmaster, Mr A. Driver of Tewkesbury. I have

expressed my earnest wish that the good feeling which has always existed in this school may be continued.' Reverend Dighton had been a regular visitor and loyal friend to the school for many years, and in fact the school enjoyed a day's holiday on 20 September 1915 to celebrate his ninetieth birthday.

Other local personalities visited regularly and made contributions of their time and money to the benefit of the children. Foremost among these were Mr and Mrs Cridlan, who lived at Maisemore Park and were the breeders of the renowned Maisemore herd of Aberdeen Angus cattle. The Cridlans regularly hosted events for the whole school at Maisemore Park. At one for the presentation of the Tibberton Attendance Shield, which the school won again in 1914, a Mr Sawyer had composed an acrostic which was quoted over the years by the pupils:

> **M**aisemore school has won the shield
> **A**nd we're proud and we will be
> **I**ndustrious in all we do.
> **S**o when school ends you will see
> **E**xcelsior shall be our aim.
> **M**eanness we will always spurn,
> **O**bedience, truth and beauty learn.
> **R**ough our way, we'll never yield,
> **E**ver will we play the game.

Other prominent supporters included Mr and Mrs Pearce Ellis of Maisemore Court and Mr Horace Barnes. Mr Barnes was a retired timber importer and Freeman of the City of Bristol, who in his day had been a distinguished sportsman, particularly good at tennis and cricket – he had played alongside W. G. Grace. He attended church morning and evening whatever the weather and became a regular visitor to the Church of England school, offering encouragement on many fronts. He had retired in 1914 just before Mr Driver came to Maisemore, and after that he threw himself even more into village activities, with particular interest in the school. Even today, former pupils recall him with affection, how he was always dressed in plus-fours, and how he could hold their interest when he talked to the class on his visits.

In March 1916, Reverend Dighton died, but his successor Canon Billett took just as much interest in the school and continued the support. A canon was a novelty for the children, and when they first heard that a 'cannon' was coming, they immediately dubbed him 'Gunner', a nickname which pupils used for many years, but never to his face. Mr Driver quickly became a valued member of the community. Many years later he recalled that when he was first appointed to the school, he intended to remain there for only about two years but a villager told him, 'Maisemore will get you. You will never want to leave.' And so it proved.

The War Years

Although he was only twenty-three and relatively inexperienced when he took up his post, Mr Driver had a clear vision of the way he wished to develop the school. From the outset he was a strict disciplinarian, quickly earning the nickname 'Boss' Driver, which was used by generations of children, though they were careful not to let him hear it. He firmly believed that he was there to teach and the pupils were there to learn, and he would tolerate no interruption that diverted attention from the learning process. He was quick to identify and address shortcomings and to introduce new topics of study. School records during the war years show the steady diversification of the academic work alongside a growth in food production, both as part of the children's education and to contribute food to the war effort. He himself was an avid reader – a family story recalls that he once fell into a hole as he walked along, absorbed in reading a book. He read stories every morning to the children, establishing for many a life-long love of books. There was more music and drama than previously – an annual Shakespeare celebration at which the pupils sang various Shakespeare songs and acted pieces from the plays, and regular concerts – but it is not until after the war that records indicate the extent of improvement.

Although his poor eyesight had already made him unfit for active service, Mr Driver tried to enlist in Lord Derby's Recruits at Bristol in March 1916. In July 1915 the government had passed the National Registration Act and all men between the ages of fifteen and sixty-five were obliged to register and give details of their employment. This showed that there were almost 5 million men of military age who were not in the Forces. In October that year, shortly after these results became available, Lord Derby was appointed Director-General for Recruiting. He could see that voluntary recruitment was not going to raise the numbers of men needed and devised what came to be known as the Derby Scheme or Derby Recruits. All single men aged between nineteen and forty-two, other than those in reserved occupations, had two options: they could enlist immediately in a regiment of their own choice or wait until they were called up, when they would be assigned to any regiment. Men who signed up under the Derby Scheme were sent back to their homes and jobs until they were called up. The scheme was extended to include married men in May 1916, but by then Mr Driver had already applied. When conscription was introduced, he again attended an Army medical examination in December 1916 and was again rejected. But at Maisemore, he made sure that the pupils contributed as much as possible to the war effort. From October 1915, the girls were to devote one lesson a week to knitting scarves and socks for the soldiers (with valuable help and guidance from Mrs Cridlan), and by December over thirty items were ready for despatch to the Western Front. This was the first of several packages of knitted goods sent from the school. There were special lessons on 'The Army' and 'The Navy' and regular collections for the troops. One of several

fundraising efforts raised £1 18s, which was sent to the Over-Seas Club 'to provide tobacco for the troops' in December 1916. There were special talks on 'War Savings', and indeed in May 1917, when food shortages were becoming serious, Mr Driver recorded in the school logbook that he had asked the children to refrain from lunch on Mondays during the crisis, and all the children were doing so.

Outside the classroom, activities flourished. The Poultry Club had quickly become well established and the sale of eggs in the 'Children's Egg Weeks' in February 1916 and 1917 raised £2 10s each time for the care of wounded soldiers. The school's livestock expanded in June 1916 when Mr Driver started a rabbit club, and to add to the children's farm skills, a milking class was also started with the co-operation of local dairy farmers. For the duration of the war, several of the older children were granted exemption from school attendance to work on the farms and Mr Driver obtained permission to close the school for two days on more than one occasion to take all the children 'potato-dropping', dropping the seed potatoes in rows. In rural areas it had always been normal practice for children to help in the fields and there were, for example, well-established hay-making holidays. In the summer of 1917, however, Maisemore School (and many other schools) closed particularly early each day, so that the children could engage in agricultural work. This was their contribution to help counter the food shortages, the result of German submarine warfare that had caused a massive decline in food imports. The natural progression was to start gardening lessons at school, and with the encouragement of Horace Household of the Education Committee, these started in November 1917.

According to contemporary records, the children of rural schools in Gloucestershire were asked by the government to pick blackberries for the use of the Army and Navy, and half days were granted for this purpose once a week throughout September and October in the war years. Mr Driver records that the school was duly closed and the children went blackberrying. He does not indicate how much they picked, but nearby Sandhurst School on the other side of the River Severn recorded a total collection of 1,043 lb over a six-week period in 1918, so it was clearly a fertile spot. The pupils at Maisemore were rewarded with a day's holiday in December 1918 to celebrate their 'exceptionally fine pick of blackberries'.

During the war the children saw lots of soldiers marching and training in the village. In fact Maisemore is immortalised in the poem of the same name by Gloucestershire poet Ivor Gurney. In it, he recalls the men marching through the village and across the bridge as the villagers cheered, and shows how much the village meant to those who went to war but did not return. Trenches were dug on the hill and, after the soldiers left, the children played in them. Life on farms, however, went on much as before, but the war did not leave Maisemore unscathed. The war memorial records the names of twelve young men, including Lieutenant Clarence Cox, who was the son of Mrs Cridlan by her first marriage, and at least one, Sergeant Jack E. Richards, who had children at the school. Mr Driver was to prove a great support to the Richards family and had in fact written to

Mrs Richards when her husband was killed in Italy to say that he would do his best to look after the family. He kept to his word, ensuring that the children had the opportunity of further education, which might otherwise have been impossible. After all the fundraising and generosity towards the troops overseas, it must have been interesting for the children to have a visit in November 1918 from Captain Cecil Barnes, son of Horace Barnes, who recounted his experiences of four years as a prisoner of war. After that, Captain Barnes was a fairly regular visitor to the school.

As Maisemore was a Church of England school, religion underpinned all the activities. There were scripture lessons every morning, and all children paraded to church on Christian festivals such as Ash Wednesday and Ascension Day, then had the afternoon off. Church and school were closely united. Attendance at Sunday school, both in the morning and in the afternoon, was the norm. Once a month there were services held in the church, and on the other Sundays the meetings were held at the school. Over the years many of the pupils sang in the church choir, and as Mr Driver was also in the choir, one of them recalled that they 'seemed to be perpetually under his thumb'. The vicar visited the school at least once a week. Reverend Dighton, who was still the incumbent when Mr Driver arrived, was an old-style Victorian vicar with a long flowing white beard and a top hat. He sometimes caned the boys with his stick and one pupil, Gilbert Probert, recalled in later years that he had been particularly strict with his brother, who had the misfortune to be left-handed in less enlightened times. After Reverend Dighton's death, Canon Billett took over the regular visits and gave weekly scripture lessons. He got on well with Mr Driver, who had quickly become a leading member of the congregation.

When Mr Driver arrived at the school there were two other certificated teachers: the new infants' teacher, Miss K. M. Knight, who had replaced Miss Emery in late 1914, and Miss Lottie Poole, a local girl, daughter of one of the Maisemore blacksmiths. As young women were required to resign on marriage, a heavy turnover was noted in most schools. Maisemore was no exception. Over the next few years, Miss Knight left, then Miss Poole. Their replacements, Miss I. Ashbee and Miss Preston, stayed for eighteen months each and Miss Olive Billett, daughter of Canon Billett, was a teacher for a year. Then in April 1918, Lottie Poole returned as the infants' teacher. She had not married but for two years had extended her experience by teaching at a Gloucester school. She was a very small woman and quickly acquired the affectionate nickname of 'Tottie' Poole to generations of schoolchildren, again never to her face. Her arrival marks the beginning of a partnership that was to last for over thirty years.

Evidence of Change
in the School and the Village

As early as 1916, Mr Driver had had an idea that was to have a big impact on the community: he persuaded Mr Pearce Ellis of Maisemore Court to put up £100 interest-free so that he could start a Pig Club for adults in the village. Within a week he had the names of fifty would-be members. From then on, many of the villagers made weekly payments into the club and in due course those who did not already keep pigs were able to buy a pig at Gloucester Market, benefiting from the expert advice of one of the local pig farmers. This soon expanded to a Pig and Poultry Club. The cottage gardens were usually large enough for a pig and some chickens, and once they had the stock, the villagers were able to buy the feed at a reduced cost, as Mr Driver undertook the buying in bulk of feed and, even better, took over all the form-filling and accounts and dealing with the Ministry inspectors. This would expand before long to include the buying of seeds, seed potatoes and fertilisers; all this was then stored in a shed near the school, the 'Meal Shed', which still exists today.

School supplies for the gardens and livestock were also delivered there to benefit from the bulk-purchase reduced prices, but were then transferred to sheds on the school land. The pupils were very familiar with the Meal Shed, either through the school or through their parents' purchases, and they regularly had the job of creosoting it. A former pupil says that they creosoted it so often that he expects it will still be standing long after they are gone. Mr Driver managed the ordering and kept the accounts, and distributed the feed and corn on Saturday mornings from the Meal Shed. He set up two other clubs for the village that were run from the school, a Coal Club and a Clothing Club. From about Easter children would bring in a shilling or two a week, so that by the winter the families would have saved enough to buy a ton of coal and some clothes. The school became the focal point of a whole host of activities for the benefit of the community.

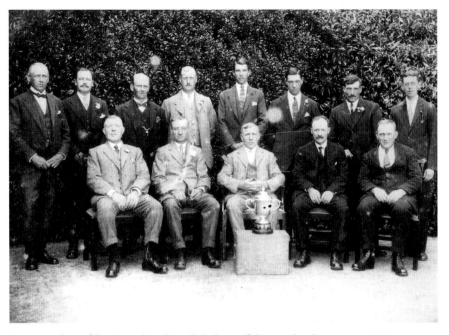

Some members of the Pig and Poultry Club show off the cup they have won, *c.* 1922.

By 1919 there was evidence that the academic standard in the school had improved dramatically. Two girls won scholarships to further education at the Commercial College in Gloucester, the first scholarships won by Maisemore pupils. One of these was Doris Richards, daughter of the war casualty Sergeant Richards. Mr Driver had promised that he would look after the Richards family, and his encouragement and support meant that, even though Doris was unable to fulfil her dream of becoming a teacher, she was able to train as a shorthand typist and, later, a secretary. There were annual school inspections by HM Inspectorate, but these had been suspended at many schools during the war. They were, however, resumed in 1919, when Dr Leicester, one of HM Inspectors of Schools, highlighted the improvement in achievement at Maisemore:

> This is a good school. The Headmaster is thorough in his control and enterprising in his methods. The children are alert and enter keenly into the many activities of the school, and the work throughout reaches a very satisfactory level. The term examinations are carefully conducted and the Head teacher's reports are complete and helpful. The children co-operate in poultry-keeping. They write and edit a school magazine and some of them write pleasing original verse. In the ordinary school work, the accuracy of the arithmetic and the freedom of the composition are worthy of special mention.

Although he notes that 'the work of Standards II and III is relatively not as good as that of the upper class', he also mentions that 'The Infants' class and Standard I are in good hands, and the little ones are making an excellent beginning'.

This is in contrast to the same inspector's report on the school in 1914 prior to Mr Driver's arrival:

> Children are well-behaved and appear to do their best, but utterly fail to express themselves orally and to show what they have learnt. They need more training to show what they mean … The infant class is not taught satisfactorily.

Gilbert Probert, a pupil at that time, who had witnessed the transition from Miss Gardner to Mr Driver, later wrote:

> The school was run more efficiently. We had more books, and slates went out and we had a library of books to borrow to read at home. The books in the library were changed completely each term and a new lot brought in. We had football and cricket at school which was quite something in the war years. [Mr Driver] also organised a village football club and cricket club and ran these over a number of years. The headmaster was ready to and did help anyone in the village who needed help, not just by giving advice but by personal effort and if need be, money.

This last comment is of interest. Mr Driver was not a wealthy man, but he used what money he had to the benefit of others. Local residents believe that he made contributions to all sorts of things and helped individuals with cash, but as these arrangements were discreet and strictly private, there is no actual proof. His descendants do, however, recall that his generosity to others caused a bit of friction at home, especially as he now had a son to care for, George Alfred Percival, known as 'Bink', who was born in December 1917. To back up his assertion, Gilbert Probert comments that the year after he started at Junior Technical College, he and his friend, Norman Richards, the son of the late Sergeant Richards, were asked for the annual fee for materials. The families were surprised, as they had not paid it the previous year. It was Gilbert's firm belief that this had been paid for them by Mr Driver.

The school magazine, the *Maisemorian*, was first published in 1919. Unfortunately there are no copies of the first edition, but the earliest surviving copy from 1921 gives a good indication of how much had already been achieved by the pupils. It was put together by an editorial committee of pupils, and they appointed an editor – in that year, Gilbert Probert. Mr Driver himself always copied out their final version for duplicating – the handwritten text looks the same in 1921 as it would in 1942 – but the editor's decision was final. The pupils wrote articles about school activities, prize-giving, the annual outing, sports, a joke page and poems. These articles reflect

the level of involvement of others in the community, as the pupils are always careful to thank all those who had helped with time or resources. In fact, the almost family atmosphere is shown in the 1923 edition, which includes 'Hearty congratulations to Mr G. Pearce Ellis on his fine success in the Intermediate Examination of the Institute of Chartered Accountants'. But what sets the *Maisemorian* apart from other school magazines is the round-up of the successes – and sometimes failures – in the garden and with the rabbits and poultry. Mr Driver had secured a corner of a ploughed field as a school garden. He was a knowledgeable gardener and was able to teach the boys the theory, as well as practical work. The pupils also had the advantage of free use of Maisemore Court Farm manure heap within 100 yards of the school gardens.

The 1921 *Maisemorian* entries, completely written by the pupils, show a good level of confidence and understanding of gardening methods and how to deal with the many garden pests. It is worth noting that the pupils comment that the produce was easy to sell and that they made a profit after accounting for costs. This business aspect of gardening and all other rural activities was established from the very beginning of the school's activities in this sphere:

> All our crops have appeared and some are yielding us produce which quickly finds a buyer. During their infancy, the plants received sufficient moisture to

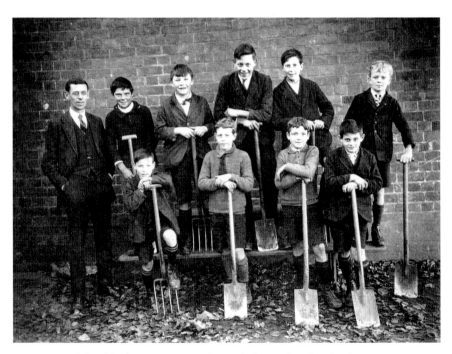

Mr Driver and the older boys, *c.* 1920. Gardening had started at the school in 1917.

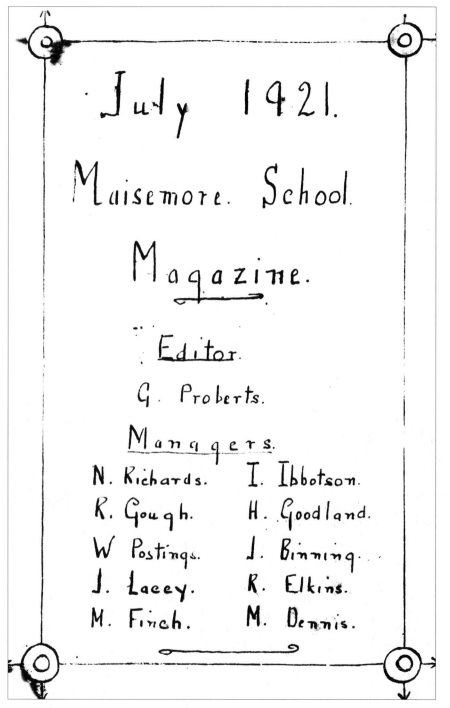

The front cover of the 1921 *Maisemorian* lists all the pupils involved in its preparation.

carry them along, but since then the extremely dry and hot weather has done great damage. It is of little use to water; the only thing we have found to assist the thirsty plants is the dutch hoe; this tool fills the cracks in the soil and prevents moisture escaping. This dry weather has also caused numerous pests to visit us, the chief being the celery fly, the carrot fly, the onion fly and cabbage aphis – the latter has practically destroyed our brassica family. In spite of these difficulties we have had some good crops of peas, broad beans, carrots and potatoes, and the cash these realised has more than paid for the outlay.

The magazine also gave brief accounts of the activities in the rabbitry and with the poultry. As with the garden produce, the rabbits and eggs were sold to cover costs and make a profit.

In the rabbitry we have just killed the last of our rabbits and are expecting some more shortly. The five we have just disposed of were good ones, being on average 5½ lb in weight and only 3 months old. They were fed on sharps, barley meal and household scraps in the morning and on good green foods such as dandelion, cabbage, lettuce etc. at night. We have just given the hutches a thorough clean and now they are ready for the next litter.

Our fowls are still laying splendidly and we are getting from our 20 birds 12 eggs per day. They have already reached 3,000 and still have 6 weeks to go, so this will be our record season. We still feed a cold mash of sharps, bran, spice and household scraps in the morning and mixed grain in the evening. The hens have suffered severely from the heat, but thanks to the use of a little bone meal and Epsom salts we have cured them. Our chicks numbering 42 are some fine birds and look promising for the winter as a large percentage of them are pullets. The RIR [Rhode Island Red] Leghorn and the Wyandotte Leghorn cross also promise good results. The ducks and geese are going ahead splendidly. They will soon be fit to kill.

In fact, in 1921 they looked after seventeen of the previous year's birds, forty-two Leghorn and Wyandottes hatched that year, and sixteen Aylesbury ducks.

The above reports were written by the pupils aged from ten to thirteen years. Clearly there have been some problems, but that is the way life is in agriculture, and the pupils have stoically carried on, and put losses down to experience. They have learnt how to care for their poultry. Mr Hollingworth, the Gardening Advisor, visited to inspect the gardens and to judge the individual plots, and his detailed comments complement the children's writing, giving the bigger picture as to how the food production became an integral part of school life: the pupils kept their own accounts (arithmetic), did their own marketing (English, communication), and so on.

In his report Mr Hollingworth noted that the Maisemore school garden was run without cost to the County Education Committee, and that Mr Driver

himself had played a crucial role in establishing the activities as he had advanced £3 for seeds and manure. Although there were single plots, there was also a common plot where vegetables were grown in larger quantities than possible on the single plots. Much of the produce was sold locally, and the surplus was sold to a greengrocer in Gloucester. Mr Hollingworth was also pleased that they had thought of the problem of school holidays: 'Four boys are appointed by the remainder to come each week during holidays to take off and dispose of produce that would otherwise spoil, and are paid at a rate agreed upon out of the proceeds.'

Mr Hollingworth went on to say that eight girls of ages ranging from eleven to thirteen took care of the poultry, and once again Mr Driver had supplied the initial funding himself, giving a loan of £5 to buy the first pen of birds and appliances. (In 1921 a total outlay of £8 was a considerable sum for a teacher to put forward personally.) The loan was, however, quickly repaid, the stock was increased, and additional pens were provided out of profits. As in the garden, holiday cover was supplied by two girls appointed by the others, and they were paid an agreed sum by the treasurer. In all the activities Mr Hollingworth perceived 'a spirit of mutual comradeship and trust between Teacher and Scholars which approaches the ideal in Elementary School life'.

Mr Household of the Education Committee was similarly charmed by the work at Maisemore:

The children have the fullest scope for developing their own capacity. They are not told what to do, nor are things done for them. Confidence is reposed in them, and they have proved that it may be wisely and safely reposed. There has been no nervousness about letting them conduct certain operations lest mistakes should be made, and the mistakes have not been made. Even if there had been mistakes (sometimes there will be) the gain in the development of character would have outweighed any material loss.

Mr Household finished his report:

It is most interesting to note that very similar results are being obtained in the ordinary work of the school. Maisemore is one of the schools which has applied with the fullest understanding and confidence the principles of Miss Mason, who has shewn [sic] us that the children can do so many things that had been thought too difficult for them without any obtrusive help, if only we will let them.

The New Educational System – PNEU

The 'principles of Miss Mason' referred to above mean the principles of the Parents' National Education Union (PNEU). This was a system of education devised by Charlotte Mason, a pioneering educationalist based in Ambleside in the Lake District, as a way to help parents who wished to educate their children at home. The PNEU motto is 'Education is an atmosphere, a discipline and a life', which Miss Mason explained as follows:

- Teachers should use educational opportunities from the child's own environment, but not reduce the world to the child's level.
- Children should be trained to have good habits and self-control.
- Education should apply to body, soul and spirit with a varied curriculum of many subjects.

This last point in itself would seem revolutionary to some. Many teachers still in post in the early twentieth century had been teaching prior to the 1891 Elementary Education Act which made grants available to all schools to enable them to cease charging for basic elementary education. Before that date, school funding had been dependent on the results of HMI inspections. It was a system of 'payment by results', and the amount of the grant awarded to each school depended on the pupils' success in reading, writing and arithmetic. Poor results meant a reduced grant or even no grant at all, and many schools therefore concentrated only on the 3 Rs. In fact, it was not unusual for an inspector to criticise a school for including far too many subjects.

But in the PNEU system the syllabus was extensive and varied, and books were supplied from Ambleside. The PNEU system moved away from rote learning and did not spoon-feed answers to the pupils. The aim of the new approach was to teach children to study and find things out for themselves. In one of the many volumes of educational philosophy written by Miss Mason, she says:

> Perhaps the chief function of a teacher is to distinguish information from knowledge in the acquisitions of his pupils ... The child who has got only information will write and speak in the stereotyped phrases of his text-book, or will mangle in his notes the words of his teacher.

Emphasis on narration was a key point in Miss Mason's philosophy. She frequently reiterated that children should 'tell back' after a single reading or hearing, or should write some part of what they have read, 'as knowledge is not assimilated until it is reproduced. A single reading is insisted on, because children have naturally great power of attention, but a second reading makes them lazy and weakens their ability to pay attention the first time.'

The PNEU system stressed that there should be no attempt to reduce the work of any age group to a supposed 'child's level'. Nevertheless, some of the book choices may seem surprising today. For example, it was suggested that Form IA (the PNEU designation for approximately seven- to nine-year-olds) should hear and tell chapter by chapter *The Pilgrim's Progress*, while Andrew Lang's *Tales of Troy and Greece*, a very big volume, could be tackled from term to term. The guidance notes on the syllabus for nine-year-olds suggested that 'they read their own geography, history, poetry, but perhaps Shakespeare's *Twelfth Night*, say, Scott's *Rob Roy*, or *Gulliver's Travels*, should be read to them and narrated by them until they are well into their tenth year. Their power to understand, visualise, and "tell" a play of Shakespeare from nine years old and onwards is very surprising.'

Miss Mason was in touch with the realities of life and knew that schools would be more likely to participate if costs were kept low. And indeed, schools soon came to appreciate the value of the schemes of work, booklists and practical guidance. In Horace Household, Miss Mason found one of her staunchest supporters. An experienced qualified teacher, he had been an Education Inspector in Bath prior to his appointment as the first Secretary for Education in Gloucestershire, and he was passionate about promoting the best possible educational opportunities. He believed in the PNEU scheme, and the moderate outlay required was another factor in its favour as the county would have had to fund materials for any syllabus followed. From 1917 onwards he started signing up Gloucestershire schools at least to trial the scheme, and in 1919 he held a mini-conference so that they could exchange views on how they were getting on.

Most of the Gloucestershire schools involved as early as 1919 were in favour, but some teachers rejected it strongly, protesting loudly that it was 'designed to make the children think, but these were country children, not students, they did not need to think'. Another head teacher, worried about the apparent emphasis on book learning, complained, 'It is folly to waste the short and precious schooldays in book learning, when the child's chief need is a practical knowledge of how to meet the difficulties in everyday life … and the British Empire of the future needs workers not bookworms.' Horace Household was in fact appalled by such reactions by head teachers, but fortunately that was not the most common response. He felt most strongly the need for equality of opportunity:

There are sections of the public even yet who have not realised that there is as high a percentage of ability among the children of the workers as in any other section of the community, and that their minds, like their bodies, will only thrive on good food. There is not a food, either mental or material, that is especially adapted to the worker's child. He needs the best there is, and the welfare of the country requires that he shall have it. If anything, he needs it more than those more favoured children who are brought up among well educated people and who have access to the best of books.

He therefore made strenuous efforts to achieve county funding for the necessary materials.

Other head teachers who had initially worried about the impact of frequent examinations found that there was no cause for concern and no need to revise beforehand as the work was ongoing. They also commented that, because of the oral work, the scholars enlarged their vocabularies, could express their ideas more exactly and were not self-conscious about speaking in front of the other scholars.

In guidance for Gloucestershire PNEU schools, Mr Household subsequently wrote, 'There are teachers who are not happy till they have made certain that there is not a line, not a word, that the child does not understand. Of course they are wrong. They are wasting time and hindering the child … It is not expected that the children will grasp everything.' The PNEU programme encouraged self-reliance – another favourite motto was 'I am, I can, I ought, I will' – and required the teacher almost to stand back and watch the children flourish.

It is clear that this approach would mesh well with Mr Driver's style of teaching, and he enrolled Maisemore Church of England School in the scheme in September 1920. He firmly believed in learning through everyday activity and in giving the children the scope to make their own discoveries. And nowhere was this more obvious than in the running of the gardening and poultry clubs, where the children carried responsibility for the care of the poultry and growing of the produce, together with all the marketing and accounting. When detailed accounts are studied (the first surviving ones date from 1931), it is clear that there was a lot of thinking and arithmetic involved.

The most obvious change was in the ability of the pupils to express themselves orally. Inspections of the school prior to the arrival of Mr Driver repeatedly commented on the pupils' 'total inability to express themselves'. This was no doubt in part due to the Victorian teaching methods of Miss Gardner from a time when children should be seen and not heard. But the change is evident in every report from as early as 1919, even before the school joined the PNEU scheme.

From 1920 there were successful candidates every year in the scholarship exams for the grammar (or high) schools in Gloucester and Tewkesbury. And occasionally, if an able pupil did not wish to go to grammar school, Mr Driver would encourage him or her in some other way. For example, in 1922 the school managers noted that 'Rose Elkins, one of the scholars, a girl of very fair ability, excellent character and with some teaching ability, has been accepted by the Education Committee as a candidate for becoming pupil teacher, on the recommendation of Mr Driver and Mr Cridlan.' In addition to the visits by the government inspectors there were regular inspections by an inspector appointed by the Diocese who reported on the work and fabric of the Church schools, but paid particular attention to religious instruction. In 1920 the inspector, Reverend Ponsonby Sullivan, wrote, 'I am very pleased with the excellent work that is done in this school. Careful records are kept and very good notebooks by the children. The general answering was very good',

and in 1922, 'Four of the elder children have passed the Diocesan exam and one has gained a First class and prize, general answering being bright and intelligent.'

There were regular exams linked to the PNEU syllabus and marked at Ambleside, and the pupils did well in the national exams set for different age groups. The school managers were impressed, and recorded in 1923 that Stella Jackson (aged nine) had gained 595 out of a possible 600 marks, while Millicent Hamblin (aged eleven) had 990 out of 1,000 and Walter Postings (aged fourteen), 1,030 out of 1,100. Mr Driver introduced a prize-giving every year, with prizes kindly donated by Mr Cridlan and Mr Barnes. Speech Day was a big event, with a large attendance of parents and local supporters of the school, especially Mr and Mrs Cridlan, Mr and Mrs Pearce Ellis, Canon and Mrs Billett, Reverend and Mrs Mirrlees and Mr Barnes. In addition to prizes for usual school subjects, there were awards for the gardening (judged by Mr Hollingworth) and care of the poultry. Former pupils recall that the number of prizes swelled over the years and came to include awards for Neatness (judged by Mrs Stephens), Manners (judged by Canon Billett) and Kindness (voted for by the pupils, presented by Mrs Cridlan). These were as highly valued as the academic successes.

Mr Driver was always keen to link the children's lessons to events in the community, and the pupils regularly wrote stories and poems to commemorate local matters of note. Mr John Stephens, a retired coal merchant, presented the school with a Roll of Honour listing the names of the seventy-two Maisemore men who had served in the war. That was unveiled in a ceremony on 24 May 1921. This was followed on 5 June by a key event for the village, the dedication of the war memorial inscribed with the name of the twelve village men who had died in action. The Mayor of Gloucester unveiled the memorial and a large crowd attended. One of the poems written afterwards by the children was included in the 1921 *Maisemorian*, together with a delightful illustration. It ends:

> Our tribute of flowers at the Cross we laid down,
> From the homestead gardens they once walked around;
> But let us take heart as they sleep in yon land,
> And see that our Memorial forever shall stand.
>
> As our village grows old and we pass away,
> Our Cross will be standing, the same as today.
> May the young men and maidens halt as they pass by,
> And read those twelve names of those who went forth to die.
>
> J Lacey 1921

The author of that poem, Jenny Lacey, became a pupil teacher at the school two years later, and stayed as a much loved and valued member of staff until 1937. The

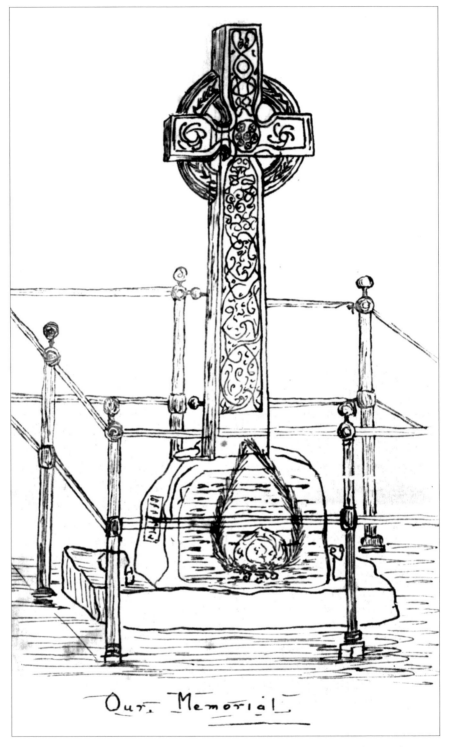

Gilbert Probert drew this picture of the war memorial in 1923 to accompany Jenny Lacey's poem.

drawing is probably by Gilbert Probert, who was the magazine editor that year, and shortly afterwards won a scholarship.

Outside School – Sport for All

In Miss Gardner's day, sport and physical exercise did not play a part in school life. That all changed when Mr Driver arrived. He had a great love of sport and quickly established a football team which played in the school leagues. From 1920 he somehow found space in the timetable for half an hour of organised games every week and encouraged his staff to attend physical culture demonstrations in Gloucester to keep up with new ideas. There was an annual sports day for the school, usually held at Maisemore Park, thanks to the generosity of Mr and Mrs Cridlan, who also provided a tea for the pupils. The rest of the community made a difference, as ever, with support and gifts of equipment. For example, Mrs Pearce Ellis donated twenty-four hockey sticks in late 1920, and after that boys and girls were able to play hockey together. An early photograph of the hockey team shows five girls and six boys. In all this they were greatly encouraged by Mr Barnes, a

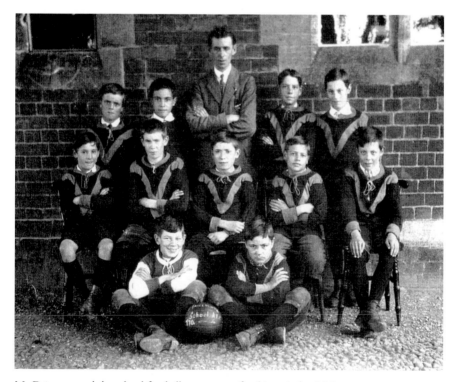

Mr Driver started the school football team soon after his arrival at Maisemore.

very keen sportsman and a frequent visitor to the school. They also played cricket. A report on the cricket team in the 1921 *Maisemorian* notes match successes, but also highlights weak areas where improvement is needed. The continuous desire to improve was ingrained in the pupils:

> The lovely weather has made this an ideal one for sport, especially cricket. Many are the hours we have put in with the bat and ball, and now we have a fairly decent XI with quite a number of promising reserves. Our girls have also shaped well, M Finch being quite equal to the best of the boys. A number of matches have been played, the majority of which have been won ... The weakest spots in the play are: the indifferent fielding – the hands should be used instead of the feet, and the returns should be rapid; the batsmen should back up more – many valuable runs and wickets have been lost through this; and the bowlers should keep on the stumps.

As always, Mr Driver was keen to give pupils every opportunity: one boy played with a plank of wood but longed for a cricket bat, and was excited to be given one by Mr Driver, stamped MCC. The boy's dream was to play with a bat from the MCC – but of course, he quickly realised that that stood for 'Maisemore Cricket Club'. It was still better than a plank of wood. Mr Driver and Mr Barnes encouraged the resurgence of the village cricket team after the war – Mr Barnes was captain of the cricket team for fifteen years and Mr Driver became the team secretary. Likewise the village football teams were revived and played in what was for a short time known as the Staunton and District League in the 1920s and 1930s, and then in the North Gloucestershire League. Mr Barnes was supportive of all sport, and he and Mr Driver appear in almost every photograph of Maisemore football teams in the 1920s and 1930s. And of course, Mr Driver was the team secretary and treasurer of Maisemore Football Club and closely involved with the running of the local leagues for many years. Later he was vice-president of the North Gloucestershire League for fifteen years and for over ten years was a member of the league's emergency committee. Although he was so keen on sport, Mr Driver did not play on the field himself. His eyesight was poor, and he always wore strong glasses. Also, as one ex-pupil recalled, 'he wasn't really built for sport', being of a slight and almost delicate build.

Another innovation was the school trip. These started some time after the First World War and, apart from the years of the Second World War, were an annual event right up to 1953. Mr Driver would hire a charabanc or several – by the 1940s, pupils remember three or four coachloads – and the whole school would go off, with some parents. The usual destinations were Bristol Zoo and Weston-super-Mare or Cheddar and Weston, or Barry in South Wales, though they once went as far as Weymouth. Ex-pupils recall that Mr Driver was 'totally different away from the school'. On these trips 'Boss' Driver shed his disciplinarian image and

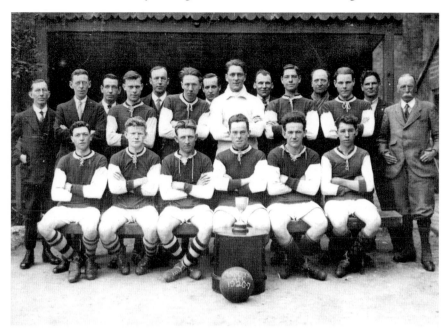

The village football team, with Mr Driver and Mr Barnes, show off the cup they won in the 1926/27 season.

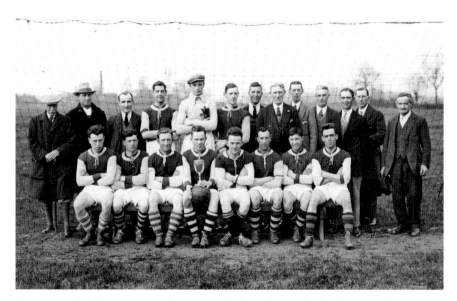

Ten years on, Mr Driver and Mr Barnes are still alongside the winning team, 1936/37 season.

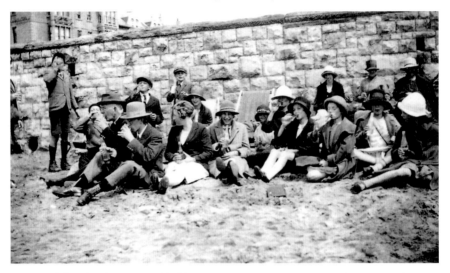

Pupils and their families enjoy a (chilly) summer outing to Weston-super-Mare in 1926.

entered into the fun. The children paid nothing towards these trips, and those who remember them with affection imagine that the cost must have been met by the generosity of perhaps Mr Cridlan, or Mr Chamberlayne, who moved to Maisemore Court in 1929, or perhaps Mr Driver himself.

There were often additional outings with small groups of pupils to plays at the theatre in Gloucester or to organ recitals at the cathedral. And of course, there were the annual trips to the Root and Grain Show in Gloucester.

Gardening and the Bathurst Shield

Mr Driver had been involved in gardening since he was a child, being the son of a domestic gardener. In addition to the theory and practical side, he seemed familiar with exhibiting produce as he had probably attended many a show with his father. In 1920, he took a group of pupils to the Gloucester Root and Grain Show to help them get a feel for the standard, and in 1921 eight pupils made their first venture to the show as exhibitors. To their delight, they won eight distinctions from their eight entries. This was the start of a run of success at the show that would last until the outbreak of the Second World War. Although Mr Driver gave the gardening lessons, he also had the enthusiastic support of Mr Hollingworth, the County Gardening Advisor, and a peripatetic gardening instructor, Mr Manning. But it was the enthusiasm of the children themselves that made all the difference. Successes in competitions began to accumulate. In 1923 the pupils won six First, three Second and two Third prizes at the Ledbury Hunt Show. One of the Second prizes was won by (George) Alfred Driver, the headmaster's son, who was only five

years old. Everyone was involved in some way. This success was followed by more prizes at the Root and Grain Show.

A glorious chapter in the history of the school is the story of the Bathurst Shield Competition. This was an award offered by Viscountess Bledisloe to encourage food production and rural studies in Gloucestershire schools and was judged by Mr Horace Household, Secretary of Gloucestershire Education Committee, and Mr Hollingworth. The competition dated from 1907, when Charles Bathurst first presented the Gloucestershire Education Committee Elementary School Gardens Trophy (the Bathurst Shield), but it had lapsed during the First World War. In 1921, Maisemore Church of England School became the first winner of the revamped Bathurst Shield Competition. The report on the gardens in 1921 praised the achievements, and the judges were also much taken with the children's business skills:

> The boys are keen on the business side [of the gardening], their knowledge of prevailing market prices is up to date and the treasurer, one of themselves whom they appointed, keeps all monies and pays all accounts … The Master's loan was paid back at the end of the first season, and after paying expenses and carrying forward a sufficient sum for seeds, etc., for the following season, the proceeds of the sales are divided amongst the members of the class on a profit-sharing basis.

Similarly, for the poultry:

> All the work is done by the girls who get orders for and sell the eggs and poultry; all the monies are received and held by one girl, who as secretary and treasurer pays accounts for food, etc., and when the yearly balance sheet has been passed and audited and an amount agreed upon has been carried to reserve, the balance is divided amongst the members of the class in the form of a bonus.

In 1922 the school again came first in the Bathurst Shield competition, but could not hold the trophy as no school could win it in the two years following their win. However, Mr Household noted in the competition report, 'No other school can as yet rival Maisemore. All that was said last year remains true. The greatest credit is due to Mr Driver and to the children, from the infants upwards.' He also added, with reference to Maisemore's contribution, that the competition 'has always provoked original and intelligent experiment, and the new ideas and new methods which have been developed have spread from school to school to the benefit of scholars and education at large'.

In 1923 the Bathurst Shield Committee reported:

> So far no school has quite reached the standard of Maisemore School, which would have had the shield but for the rule of the Committee that a School winning

the Shield is debarred from holding it again for three years. Maisemore goes as near attaining an ideal as any School can go – the ideal which the competition was intended to put before all rural schools. It does in the most practical manner what [is sought by] those who urge that a practical bias should be given to the teaching of rural schools, and it does it in a thoroughly educational spirit. There is no cutting down of the work inside the school, no denial of the joys of learning to the country child.

This last point was very important to Mr Household, as he firmly supported equal opportunities for all, and was delighted that the educational attainments at Maisemore matched the rural studies successes. In his personal diary Mr Household added:

The garden is wonderful. It is one common plot this time, and each crop is separate. The interest is as keen as ever and the few boys of twelve take in the nine-year-olds as partners on equal terms. Better gardening and better crops there could hardly be. No business hint is ever lost. As Mr Driver says, if you don't go forward, you go back (and he and his children don't mean to go back).

If anyone should think this all sounds like child labour, then his final comments should dispel that view, as he stresses how much the pupils enjoyed and took full responsibility for their garden: '[Mr Driver] does not have to come out to look after his class. It looks after itself and boys come in the evenings and on holidays to work – till he even has to stop them lest they should be overtired and injure health.'

Mr Household's enthusiasm for the school and the highly favourable reports from the Board of Education inspectors ensured that Maisemore C of E School was one of the schools selected to send an exhibit to the exhibition of schools' work at the Imperial Education Conference in London in 1923. Although it is not known what the exhibit was, newspaper accounts refer to the fact that rural schools demonstrated a bias towards gardening and livestock, 'where their handwork includes making beehives, and they learn how to keep chickens, rabbits or even pigs'. Maisemore was not alone in these pursuits, but was definitely one of the most successful.

In the school magazine, the pupils themselves gave a matter-of-fact account of progress:

A busy and successful time we have had in the garden. Our broad beans and peas did well, also the early potatoes which were of a good size. In spite of the dry weather, the marrows and runner beans are bearing well, the former having escaped the aphids. Our onions, thanks to dressings of nitrate of soda and a mulching of short manure, are well up to the standard, and the leeks which have

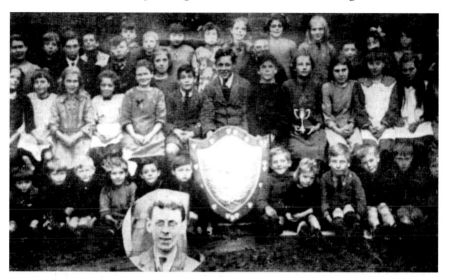

A local newspaper picture celebrates the 1924 presentation of the Bathurst Shield.

been collared, and celery are much better than last year. All the brassica family look well and the outlook is good.

By 1924, the pupils had proved their capability to the extent that they were asked to run a seed potato trial for the county authorities. When that year they again won the Bathurst Shield, Mr Household wrote:

> One feels that both in the gardens and among the livestock, one is dealing with professionals, but the children have become the professionals, and there is no problem which presents itself that they will not deal with in a thoroughly businesslike and intelligent way.

And so it continued, eleven prizes at the Root and Grain Show in 1925, top in the Bathurst Shield, same again in 1926, when Mr Household wrote, 'Maisemore, which first won the Shield in 1921, is still unrivalled and even unapproached. Mr Driver and his pupils really have achieved the ideal that was before us when the competition was instituted'. The school continued to come first in the Bathurst Shield competition, even though, under the rules, its name could not always be inscribed on the trophy. In 1929, the chairman of Gloucestershire Agricultural Committee presented the shield at the school before a large gathering of pupils, parents and friends.

In 1931, the school won the competition yet again and the official write-up says much about the progress at the school and the support of the community. Mr Household and Mr Hollingworth were much taken by the obvious competence

and independence of all the pupils. They carried out their inspection visit on an afternoon when the older children were busy with the outside work. Mr Household wrote:

> Apple trees and roses have been added since last I saw the garden. One boy was by himself on the big onion plot which was in his sole care; several boys were in one fowl house and some girls in the other, clearing out old straw and soil and creosoting timbers and perches, and the new soil was being wheeled in. Ninety eggs are taken daily from some 150 hens. No vermin at all.

There was a further formal presentation by Colonel Lloyd Baker, chairman of the Education Committee, after the school won for the tenth time in 1932. The competition ceased around that time, and after the war, in 1949, the Bathurst Shield was presented to the school to remain there indefinitely.

Meanwhile, the pupils achieved wins at other shows: in 1927, the school won the Challenge Cup at the Ledbury Hunt Show, awarded to the school with the highest number of points in the children's classes. They won this cup for the next two years, and in September 1929 Mrs Gwynne Holford of Hartpury House presented the school with a cup to celebrate their successive victories at the show. Meanwhile, they won eleven prizes at the Root and Grain Show one year, thirteen in 1929, fourteen in 1930, and by 1931 six of the school's thirteen prizes were in Open Classes. Such was the level of achievement that from 1932 to 1938 the annual school

The prize onions at the school were treated with a special fertiliser.

logbook entry reads 'Great success at Root and Grain Show'. This does not show complacency on the part of Mr Driver, merely the fact that the logbook entries were meant to record anything out of the ordinary, and success of the pupils at the show had become the norm.

The Birds and the Bees – and the Pigs

Impressive though the school garden was, it was only a part of the pupils' varied rural activities that were celebrated in the Bathurst Shield competition. In 1923 the girls wrote in the magazine:

> We are doing well in the poultry yard. Our birds are in good health and the output of eggs is satisfactory. The pullets look well and will soon be laying. We have disposed of our early hatched cockerels and ducks at good prices. The feeding is the same, dry mash and grain. Our test hens continue to do well, while at the recent shows, we have won a First, Second and Third and three reserve prizes. The new house is now completed, and it reflects credit on the builder, Mr Collett, to whom we extend very many thanks.

There were awards for poultry at the Root and Grain Show, but Mr Driver took pupils further afield as well. That year the Poultry Club gained Second prize at a show in Bristol, and the following year they gained Distinction in a pullet class at Birmingham Show. It is not clear how these trips were financed, but the cost either came out of the profits or from Mr Driver's pocket. The pupils did not pay.

The school received regular visits from Mr Price, the County Poultry Instructor, who gave lessons on 'dressing' and 'trussing', although no birds were actually killed at the school. Mr Household noted that the poultry, too numerous to count, looked as clean as any house pets. A considerable number of ducks was also made ready for market, and they were kept in a wired enclosure that Mr Pearce Ellis of Maisemore Court had allowed to be put in one of his fields. Although the girls were in charge of the poultry, the boys helped with the repair of the poultry houses as required.

Proof of the pupils' ability in poultry care came in 1924 when they won the Cup, Gold Medal and certificates in the Gloucestershire Laying Test. The specific wins were recorded with pride by the school managers:

> Honours in Egg Laying Test: Oldacre Challenge Cup for 1st pen in the Amateur section of the County, Gold Medal for 1st pen of Heavy Breed, Certificates for individual birds. The 1st pen, (five birds) had produced 1,022 eggs. One bird in 48 weeks laid 258 eggs.

The school followed this with a silver medal in 1927 and a gold medal in 1928.

As early as 1922, Mr Driver had taken the older boys to special lectures on pig-keeping and bee-keeping. Pigs were introduced shortly after that, and on a visit Mr Household was impressed by the spotless pig pens and rabbit hutches and 'four fine fat pigs of seven score (140 lb), beautifully kept'. The matter-of-fact account in the 1923 *Maisemorian* notes: 'Two pigs have gone. They were very nice baconers, about eight score each. The price made was £12 14s which amount just cleared us. The cot has been cleaned ready for September when we intend to purchase six small "stores" [piglets] and pork them.' A local farmer went to market and chose six-week-old piglets for the pupils. These were fattened up for three to five months and sold for bacon. Despite this success, Mr Household sadly noted that there was no sign of more Gloucestershire schools taking on the rearing of livestock: 'This is disappointing given what has been done at Maisemore, which has turned out boys who have found their natural bent in the garden and poultry yard and who have gone into remunerative employment.'

Although Mr Driver took pupils on several occasions to lectures on bee-keeping, it was not until 1928 that bee-keeping commenced at the school. Mr William Pymont, the County Rural Studies Advisor, brought the stock and supplied the essential protective clothing. He gave the initial training to the young bee-keepers on how to prevent swarming, how to look after the queen, and how to extract the honey. And within a couple of years Mr Household was able to write: 'Bee-keeping of which Mr Driver knew nothing a few years ago has been established with the usual result – interest, mastery, profit.'

The 1931 report of the Bathurst Shield judges is more extensive than usual and goes into detail about the results of the pupils' labours. As previously, Mr Household was greatly impressed by the business acumen of the pupils and the fact that they were comfortable and competent in handling the financial side of things. 'Very big sums of money are spent and received. Over £180 received for poultry with a profit of £40. It is amazing how smoothly and efficiently this very big business runs.' The eggs were sold to Cheltenham Cooperative Egg Market (whose lorry called regularly), garden produce to the Spread Eagle Hotel in Gloucester, the pigs to Farrow & Co. Ltd in Bristol, and the honey was sold locally. Mr Household added:

> As the accounts show, these boys and girls handle large sums of money, for they buy and sell, and they have committee meetings and keep minutes of proceedings. Any boy or girl who stays at school till 14 years of age may leave with anything from £5 to £7 to his or her credit in the savings bank, besides the capital of invaluable experience and a trained habit of mind and body. Out of the net profits of £66 7s 0d a bonus of £20 was declared and paid to the members of the Gardening and Poultry Classes. The thrifty industrious habits and the intelligent outlook have their effect in after life. A boy of 18 who opened his first Savings Account with money from the Garden Fund recently told Mr Driver that he now has more than £160 in the bank.

The competition report also included details of a survey of the direct effect of the school activities upon village life. According to responses, over thirty cottagers were now keeping fowls, these being cared for in many cases by members or ex-members of the school Poultry Club. By 1931 the Maisemore Pig and Poultry Club (for the adults in the village) had a capital sum in cash of more than £250. It made good use of its funds; for example, by the aid of a loan, it helped a former pupil set up a successful milk round. Five villagers had taken up bee-keeping, including three ex-scholars. Two were keeping pigs as a result of school activities. And some boys, on leaving school, had started gardening, albeit as a hobby, but specialising in commercial lines.

The report also listed ex-pupils who had done well or found good employment directly as a result of their rural studies training at school. Several were working on poultry farms or small holdings. A girl of fourteen had gone to a Mrs Ackers at West Monkton near Taunton to be trained in poultry keeping. Two, identified only as 'F Pa' and 'C Pa', aged twenty-two and eighteen, were doing well in Ontario, where they were working their own farm, and Isabel Ibbotson, aged twenty-two, was making a good living at her own poultry farm in Caterham. The ex-pupils were much sought after for their competence and general ability to get on with things. A farmer commented to Mr Driver on the ceaseless intelligent questioning as to why and wherefore by a boy he had: 'I don't know what your system of education is, but whatever it is, it's a good one.' The whole neighbourhood benefited from the children's education in rural matters. Many went into farming or horticulture and rose to respected positions locally; Cyril Gough, for example, eventually became head gardener at Maisemore Park.

Academic Success
under a Strict Master

The education was not just about rural studies. In the classroom, considerable progress was made as Mr Driver adopted the PNEU methods. He relished the extensive syllabus and the regular deliveries of books from Ambleside. One of the books suggested for nine-year-olds was *The Heroes of Asgard*. Mr Driver appears to have gone one better than that, as Mr Household reports in 1931:

> The work inside the school is better than ever and reaches an exceedingly high level. The Infants, who used to be a rather weak spot, now do exceedingly well. I only heard one child read: she was 6½ and could read any book, and in fact read from *The Heroes of Asgard* that would have been far beyond the range of the possible there, a few years back.

Mr Driver also believed firmly in Miss Mason's ideas about the power of a single reading or narration. When former pupils are asked to recount something about their schoolwork, they recall that Mr Driver used to read them a story once and then pick on a pupil at random to tell it again to the class. They found this nerve-wracking at first, and that sinking feeling has stayed firmly in the memory for over seventy years. As they all also say that Mr Driver was very strict, it is probably safe to assume that this method encouraged very close attention. That is no doubt why numerous inspectors comment over the years about the children's ability to speak out and describe activities. With regard to discipline in the classroom, Mr Driver took his role as teacher very seriously and would not brook any interference or silliness that disrupted the process. He could be very fierce if he felt pupils were being idle or inattentive and was known to use the cane if necessary. But he was generally fair, and the consensus was that the punishment was usually deserved.

Again, Mr Household's notes provide further information about the aims and value of narration:

> Narration is not the oral or written remembrance of the words in their due order. It is the expression of what the child mentally visualised when he listened or read or looked … Narration is not a test of the knowledge gained but an integral part of the acquisition of knowledge. At this stage questions are useless – a help to the lazy and a hindrance to the thoughtful – what the child needs is time to digest it for himself. If the lesson has not been understood, narration will show where, and when it is finished, it is the teacher's part to start a discussion in order to clear up misconceptions, etc. When I see wrong methods employed – excessive explanation, excessive questioning, interruption of reading or narration – it is almost always found that the teacher does not know what Miss Mason has taught.

Although rote learning was frowned upon, learning poetry and scripture was another matter, and the pupils gradually committed to memory a large store of passages from literature and the Bible. Mr Driver also appeared to favour more writing than prescribed. The pupils kept careful nature diaries of their personal observations, and some of the entries have survived as part of the *Maisemorian*. For example, in the 1921 edition, H. Goodland wrote:

> In my insect case I have had over a dozen perfect chrysalis. One caterpillar I found on a gooseberry bush and from its chrysalis came a Magpie Moth. From some small white chrysalis numerous flies came forth. I have also been successful with the Scarlet Tiger, the Ghost Moth and have now an onion with a grub in. I have put it in a pot of damp soil and I hope the grubs will mature this season.

Study of nature and geography was complemented by local walks, and Mr Driver established a weather station in the playground where pupils took readings, recording temperature and rainfall every morning, even at weekends. At the end of each week they drew up charts for comparison of conditions over the year.

Books were the cornerstone of the system. Nevertheless, Miss Mason believed that two and a half hours a day for Class I (six- to seven-year-olds) to three and a half hours for Class III (eleven- to twelve-year-olds) was ample time for book learning. The rest of the time should be devoted to handicrafts, nature study, music and games. Charlotte Mason's syllabus expected that, by the age of twelve, children would have learned a whole range of subjects, including physical geography, botany, human physiology, and natural history, and 'will have read interesting books on some of these subjects'. She listed detailed suggestions on the expected level of attainment. Apart from the French, German and Latin, Mr Driver achieved all of the recommendations listed below, as outlined by Charlotte Mason in her *Original*

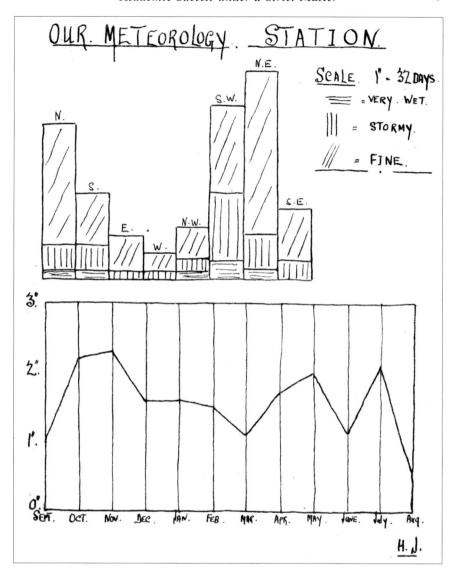

The pupils drew up weather charts every week, then made an annual chart for the *Maisemorian*.

Home Schooling Series: Volume 3 – School Education, Appendix III, published 1904:

The six years' work — from six to twelve — which I suggest, should and does result in the power of the pupils —

(a) To grasp the sense of a passage of some length at a single reading: and to narrate the substance of what they have read or heard.

(b) To spell, and express themselves in writing with ease and fair correctness.

(c) To give an orderly and detailed account of any subject they have studied.

(d) To describe in writing what they have seen, or heard from the newspapers.

(e) They should have a familiar acquaintance with the common objects of the country, with power to reproduce some of these in brushwork.

(f) Should have skill in various handicrafts, as cardboard Sloyd, basket-making, clay-modelling, etc.

(g) In Arithmetic, they should have some knowledge of vulgar and decimal fractions, percentage, household accounts, etc.

(h) Should have a knowledge of Elementary Algebra, and should have done practical exercises in Geometry.

(i) Of Elementary Latin Grammar; should read fables and easy tales, and, say, one or two books of 'Caesar.'

(j) They should have some power of understanding spoken French, and be able to speak a little; and to read an easy French book without a dictionary.

(k) In German, much the same as in French, but less progress.

(l) In History, they will have gone through a rather detailed study of English, French, and Classical (Plutarch) History.

(m) In Geography they will have studied in detail the map of the world, and have been at one time able to fill in the landscape, industries, etc., from their studies, of each division of the map.

(n) They will have learned the elements of Physical Geography, Botany, Human Physiology, and Natural History, and will have read interesting books on some of these subjects.

(o) They should have some knowledge of English Grammar.

(p) They should have a considerable knowledge of Scripture History and the Bible text.

(q) They should have learned a good deal of Scripture and of Poetry, and should have read some Literature.

(r) They should have learned to sing on the Tonic Sol-fa method, and should know a number of English, French, and German Songs.

(s) They should have learned Swedish Drill and various drills and calisthenic exercises.

(t) In Drawing they should be able to represent common objects of the house
 and field with brush or charcoal; should be able to give rudimentary
 expression to ideas; and should be acquainted with the works of
 some artists through reproductions.

(u) In Music their knowledge of theory and their ear-training should keep
 pace with their powers of execution.

This is the degree of progress an average pupil of twelve should have made under
a teacher of knowledge and ability. Progress in the disciplinary subjects, languages
and mathematics, for example, must depend entirely on the knowledge and
ability of the teacher.

From 1923 there were also cookery lessons once a week in the County cookery van
which toured rural schools. Its arrival was celebrated in that year's *Maisemorian*. As
usual, the magazine was produced to a high standard, but this piece perhaps gives a
hint of a young editorial committee:

At the beginning of July, the long-looked-for cookery van arrived. By the kind
permission of Mr Pearce Ellis it was stationed quite close to the school. Our hours
of instruction were from 9.30 to 12 and 1 to 3.30. Each morning was devoted to
cooking, and the afternoons to washing, ironing etc. and notes. In each branch of
the work, many practical and valuable lessons were learnt. The dinners we cooked
were sold and it shows how well they must have been done by the ready sale. The
following are two useful recipes:

Vim	*Furniture cream*
1 lb whiting	1 oz bees wax
1 lb silver sand	1 oz white wax
4 pkts Hudson's soap	1 oz Castille soap
Well mix together and	1 pt turpentine
put in jars	1 pt boiling water
	Well mix and store

Perhaps not the sort of recipe we were expecting.

The girls did knitting and needlework. Miss Poole was a very fine needlewoman
and imparted her skill to her pupils. Some very beautiful examples of the work
produced survive in the Maisemore homes of their descendants. From 1924 the
girls could use the new sewing machine, which was paid for by money raised at a
whist drive. The boys enjoyed woodwork, often with the practical application of
making and mending poultry cages and rabbit hutches. All played sport. And then
of course, there was the work in the gardens, and with the poultry, the pigs and the
bees.

All this activity attracted attention on several fronts. No doubt on Mr Household's direction, visitors started coming to the school to study the application of PNEU methods. At first these were from within the county, but soon people came from much farther afield. The HMI inspectors called regularly, not to inspect, but to bring colleagues and interested parties. In 1923 Inspector Wood brought a visitor from Ireland and shortly afterwards introduced several senior education officials from the West Riding of Yorkshire. For six months in 1924, Mr Driver recorded 'visitors to study method' every week in the logbook. They were so frequent that he did not note anything else about them unless they were from abroad. In 1924 a group of American ladies visited. The PNEU methods had found favour with many in the USA, where home schooling was, and still is, more common than in the UK. And in 1925 there were visitors from France. Added to the PNEU observers were those interested in the teaching of rural studies, so the stream of visitors was endless. In 1930, there were more American visitors and one visitor who was a schools inspector from Palestine. Given the scale of the rural activities, it is not surprising that the school also had regular visits from Board of Agriculture inspectors. They were impressed by the care and knowledge of the children and the emphasis on hygiene, which would be crucial, as the school was selling large quantities of meat, eggs, fruit and vegetables to the public.

Excellent Teachers, Shame about the Building

Given all the things going on at the school and the widespread interest it attracted, one might think that Mr Driver was operating in showcase premises, but in fact, nothing could be further from the truth. Although the school was achieving success inside and outside the classroom, the premises themselves did not enhance the experience for the pupils. Maisemore Church of England School was established in 1859 and was little improved in the years prior to Mr Driver's arrival. Heating, lighting and ventilation had always been and would continue to be problems. The impossibility of achieving a steady temperature or even an adequate temperature most of the time had ruled out the practicality of obtaining a piano, which Mr Driver longed to have. The school did not, however, seem to suffer from the overcrowding of some of the other local schools, though in 1907 the previous head teacher had been instructed not to admit any infants under four years of age, so as to keep the average attendance under sixty. The playground and front yard were unpaved and turned to mud in bad weather.

Between 1920 and 1925 the school managers were very aware of the deficiencies in the building and made various efforts to remedy defects. The local builders, the Hiams, were contracted to carry out various repairs, enlarge the windows, and improve the very primitive lavatories. In 1924 Mr Herbert, who rented School Cottage for £13 a year, was appointed school caretaker to keep a closer eye on

maintenance. (School Cottage was separate from the school and schoolhouse, and had many years before been the Dame School in the village.) In 1927 Mr Household noted that the playground had not been touched for many years: 'The lower part is a swamp and the upper a mass of rough protruding rock.' As a result, Mr Cridlan recommended that the playground should be gravelled, or at least 'the pools in the playground should be filled with gravel'.

Despite the managers' best efforts, the HM Inspectorate's 1929 report on the school premises was damning. The most serious problem was the heating, or rather lack of heating, in both the main room and infants' classroom. The inspector considered the heating in the main room to be seriously defective. The sole source of heat was an open grate almost at the end of the room, which was 31 feet long, and it was therefore quite inadequate for warming the whole. Carefully monitored temperature records for February 1929, taken at 9 a.m. and 4 p.m. daily, showed that the schoolroom temperature at 9 a.m. on fifteen occasions was below 45 °F, including ten below 40 °F and five 35 °F or less. Indeed, on eleven occasions, the temperature was only 40 °F or under, even at 4 p.m. The inspector expressed concerns for the children's health, but there was no suggestion that the children should be sent home because it was too cold. He recommended the installation of a Tortoise stove at the other end of the room – and in fact, such a stove was eventually installed in January 1930. (The Tortoise stove was so named because it

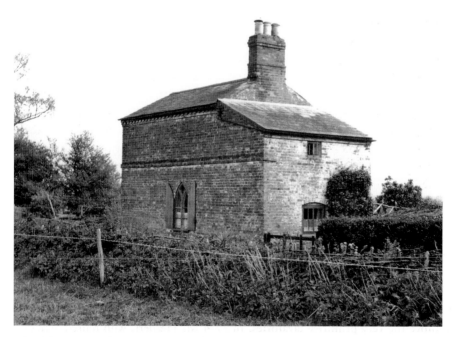

School Cottage was the original Dame School in the village.

burnt fuel so slowly, and the manufacturer's company motto was 'Slow but sure combustion'.) The infants' room was not much better as, although the room was slightly smaller, 20 feet 7 inches by 16 feet, the bars in the grate were broken, so that it was impossible to have a fire of any size.

Although the failure of the heating was the most significant defect, the inspector found plenty more to criticise: the doorsteps were very worn and admitted constant draughts, as did the original, badly fitting windows, the floor was in places very thin, and he commented that the school would seem much lighter if the inside of the roof, apparently full of cobwebs, were cleared and painted white. He also commented on the state of the long, backless desks which, he wrote, were 'in the last stages of decrepitude and should be scrapped'. They were totally inadequate. Moreover, in the infants' room there were four 'dual' desks that were quite unsuitable for young children, as they were much too high, and were meant for the much larger children in the main room. If the infants sat in them, their feet dangled in mid-air. It was typical of Mr Driver that he had found a temporary solution to this problem by constructing small platforms on which the children could rest their feet. On the inspector's recommendation, Mr Driver was able to obtain new desks from the Education Office for the start of the summer term.

After considering the HMI report, the school managers obtained estimates for much of the necessary work, though they decided to postpone re-flooring. By the start of term in September the school had been thoroughly renovated. There was of course no electric lighting, so it was usual for schools to close at 3.30 p.m. from early December to February every year because of the bad light.

Over the next few years the school managers tried to keep on top of the need for repairs, but there were always problems. Mr Driver never noted such routine things in his logbook. He knew the managers were taking action where they could, and he and the pupils made the best of things.

When Lottie Poole arrived as infants' teacher in 1918, there was a third teacher, Miss Olive Billett, who taught the seven- to nine-year-olds. Miss Billett, Canon Billett's daughter, left in 1919 and was succeeded by Miss Winifred Boardman, who after a year was succeeded by Miss E. M. Head. Mr Driver was not in the habit of recording comments about any of the staff, but the school managers noted in April 1921 that a highly unfavourable report had been received on Miss Head's teaching, and it was therefore decided to give her notice. It is not clear whether the unfavourable report came from Mr Driver or HM Inspectorate, but it is likely to be the former as the managers had great faith in Mr Driver's judgement. They were also very loyal to the school and in the face of HMI criticism were more likely to rally to the defence of the staff (as they had done in the past when there was criticism of the previous head, Miss Gardner). To replace Miss Head, the school managers shortlisted two candidates, but the final choice was left to Mr Cridlan and Mr Driver, who were very much in tune in their view of how the school should

be. They selected Miss R. Vallender, who fitted in well but left in March 1923 after less than eighteen months in post.

For some reason no one was appointed to the vacant post straight away, so the school managers stipulated that no children under four were to be admitted, as the only staff were Mr Driver and Miss Poole. Mr Household made one of his official visits in the summer term of that year and noted in his diary that there were fifty-six pupils in the whole school, and seven in Form III (the oldest ones). He wrote:

> Last year there were two in Form III and they taught themselves from the books. [These were Gilbert Probert and Norman Richards, who both won scholarships to Gloucester Junior Technical College that year. Gilbert recalled that he spent most of his last term making and repairing rabbit hutches.] This term one girl, Jenny Lacey, nearly 14 or just over, is really teaching the rest so far as they want teaching. Mr Driver runs all from Forms A and B upwards. The infants come up to him well-prepared. He does not want any other teacher besides the infant teacher but wants to make Jenny Lacey a pupil teacher.

Although there were successes in scholarship exams from 1919 onwards, there was a new ruling in 1923 that 'all children over 11 and under 12 on August 1, or over 10 and specially advanced, *and whose parents desire them to be examined*, can sit for secondary school places'. So while it is true that the ablest pupils won scholarships to grammar schools, some good pupils did not take the exam, often because the families could not afford the extra expense. Those who did not take up scholarships would stay at Maisemore C of E School until the age of fourteen. Jenny Lacey was clearly very able and could therefore guide the work of her perhaps not-so-able peers.

Mr Household finishes his diary entry with a very telling comment which throws additional light on Mr Driver:

> Miss [Norah] Smith commenced on 1 June as supplementary teacher. Mr Driver speaks kindly of her, but says she wants training. He wishes teachers would show initiative (the infant teacher does) and would not want to be told so much what to do. But he does not know enough of the world to know that such people are few and that he himself is an altogether exceptional man.

Miss Smith did not stay long, and in September 1923 Jenny Lacey became a pupil teacher. Mr Driver reported favourably on her progress to the school managers, and thereafter, with the exception of occasional students for a few weeks at a time, the school staff was composed of Mr Driver, Miss Poole and Miss Lacey, working in harmony until Miss Lacey's marriage in 1937. This made an exceptionally strong and cohesive team as, quite apart from their teaching ability, both women were

local girls: Lottie Poole, daughter of the blacksmith, and Jenny Lacey, daughter of Mr Cridlan's head gardener at Maisemore Park. They were well known and trusted by the entire village. In the meantime, Mr Driver had a rare disagreement with the Church school authorities. In 1927 Canon Sewell had visited with the vicar to look at the infants' room (where at that time there were twenty-two infants). He told Mr Driver that Standard I, the six-year-olds, ought not to be taught with the infants and that he ought to have another teacher. Mr Driver, however, did not want another teacher. Mr Household recalled that he had previously asked 'not to be bothered with one'. Moreover, Mr Household agreed that six-year-olds were better with the infants, although in two-teacher schools it was more usual for Standards I and II to be taught together. Mr Driver won the argument in that he did not have to appoint a new teacher. However, he conceded that there was a disproportionate number of infants and Standard I children, too many for one teacher. So the pragmatic solution was to nominate Jenny Lacey as a full-time teacher from January 1928, as she had by now passed her exams.

His reaction to Canon Sewell's suggestion did not mean that he was opposed to any other assistance. He accepted student teachers, some of whom stayed for several months at a time. These included a young man, G. Finch, who features in a school photograph from 1933. When a local student, Meta Stubbs, spent a year at the school to observe and learn, Mr Driver persuaded the school managers to offer her a small salary to encourage her. He believed it would be well deserved and that by the end of her training year, she would be quite capable of teaching Standard I classes anywhere. He rewarded diligence and, above all, initiative, in staff and pupils alike.

In this 1933 photograph, the children are accompanied by Miss Poole, Miss Lacey, Mr Driver and student teacher G. Finch.

Much of the information about Mr Driver and his school comes from the Maisemore Church of England School logbook. It is worth highlighting how Mr Driver's entries differ from the norm. Logbooks became mandatory in 1862, and in them head teachers were to record events affecting school life. These included changes to the curriculum or timetable, reasons for unscheduled holidays, any visits, including inspections and the resulting reports, unusual incidents, injuries to children, and awards. But the way that head teachers recorded information is highly individual and varies tremendously from school to school. Some use it as a record of work, others variously as a punishment book, attendance book, complaints book and, in some cases, as a personal diary. The head teacher at a neighbouring village school recorded one day: 'The children seem very stupid after their holiday. It will be very difficult to teach them anything.' Mr Driver kept strictly to the guidelines, recording changes in routine, trips out of school, visitors to school, awards and inspection reports. Whereas other schools would, for example, record the weekly or fortnightly visits of the Attendance Officer, such visits are never mentioned by Mr Driver, though they undoubtedly took place. Truancy was never a problem at his school. Similarly, he mentions few of the fairly frequent epidemics of flu, scarlet fever and especially measles, which regularly decimated attendance at most local schools. As a child, he himself had missed schooling as a result of scarlet fever, and his brother had had to stay at home to avoid spreading infection, a fact recorded in Stonehouse Primary School logbook in 1899. At Maisemore, one of the few recorded epidemics – of measles – is in April/May 1932, when almost half the pupils were off sick.

In the school logbook, Mr Driver does, however, fully record all the HMI inspection reports. These differ from the norm as well. Usually the inspectors gave a brief but informative note of achievements, such as 'Reading above average in Standard I', or 'Arithmetic fairly good but more practice needed in long division'. Once Mr Driver established the gardens, the poultry, the pigs and the bees, the inspectors all seemed completely bowled over by the variety of work outside the school. They lavished praise on the achievements and then usually as an afterthought noted that the academic standard was also very high. Indeed it was. For that reason, the vice principal of the Training College in Cheltenham brought a group of students to study method in the classroom in 1932. Other visitors continued to flock in; those studying PNEU teaching included more from the USA, and there were many interested in rural subjects, including in June 1933 a group of Indian students. This group apparently visited on a Saturday, and therefore at least some pupils presumably attended to show what they had done.

Although the PNEU organisation was keen to use scholarship successes as a way of proving the success of the system and to encourage more schools to join, Mr Driver's focus was on his pupils, and he had no particular interest in publicising the achievements of the school. Yet the strong academic results were confirmed by the award of several scholarships each year to Maisemore pupils. This in itself is

George Alfred Driver (Bink) in front of the schoolhouse. Despite his appearance, he was not a pupil at Eton College.

fairly remarkable, as in any given year there would only be a few pupils of eligible age. One of those was Mr Driver's own son, George Alfred, who in 1928 won a full-fees scholarship to Westwood's Grammar School in Northleach, about 25 miles from Maisemore. This was unusual, as it meant the boy would have to board away from home. Mr Driver was so busy with all his commitments that he did not have much time for family life.

National Recognition – Mr Driver's MBE

The pupils who did not leave at age eleven went on to shoulder responsibility for the gardens, pigs, poultry and bees, which gave them an excellent grounding for the future and made them much sought-after as employees on local farms. The crucial role of Mr Driver in developing all these skills was recognised in 1934 when he was awarded an MBE. The whole village was delighted by the honour. The school closed for the day on 28 February when Mr Driver and his wife attended the investiture at Buckingham Palace. In May, he was presented with a gold watch as a token of the pride felt by the parishioners at his inclusion in the New Year's Honours List. The publicity generated brought the press to Maisemore School. Photographers were familiar with the Maisemore Aberdeen Angus herd, which featured often in newspapers as champions at the Smithfield Show and elsewhere, but it was a first for the school. Although Mr Driver was meant to be the focus of attention, at least one press photographer who visited in 1934 went for the 'human interest' shot, and took pictures of the children with the chickens. (That particular photograph found its way to *The New York Times*.) In later years, Mr Driver was quoted in the press as saying that the investiture was one of the most memorable days of his career, but to his close family he acknowledged that it was a bit of an ordeal, and he would have preferred not to be singled out.

The MBE – one of only fifty-four awarded that year and so proportionally an even greater honour than an MBE today – was to 'Alfred Edgar Driver, Headmaster of Maisemore Church of England School, Gloucester'. Although it was presumably first and foremost for his services to education, Mr Driver deserved it for services to the whole community. There were few activities where he was not a leading figure – member of the church choir, member of the parish council, secretary of the football and cricket teams, organiser and supplier of the Pig and Poultry Club for the villagers – the list is endless. Mr Driver is in almost every photograph of a village activity, but this is not to say that he was pushy or seeking the limelight. Quite the opposite. He was simply a man of tireless energy who saw jobs that needed to be done and got on with them, and in so doing won the respect and affection of the village. At the school he had the loyal and reliable support of Miss Poole and Miss Lacey, and in the village, a network of staunch supporters who took a great interest in education.

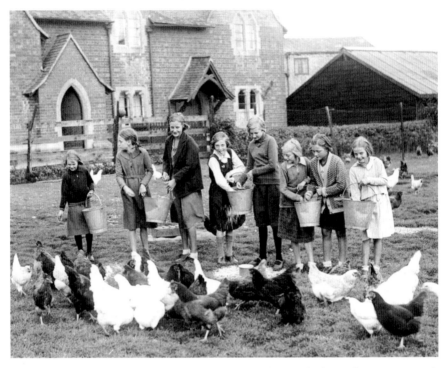

The older girls caring for the poultry, 1934. This photograph featured in a New York newspaper.

Foremost among these were the school managers, with Mr Cridlan as chairman, who did their best to respond to requirements such as repairs to the fabric of the building. Mr Cridlan was very forward-thinking in his outlook. As early as 1919, when one school manager, Mr Norman, left the district, Mr Cridlan had suggested that it would be an advantage if a lady were appointed to replace him. Mrs Percival became the first female school manager at Maisemore, and was followed later by Mrs Buchanan. Then, when another manager left in 1926, it was decided that the replacement should be the parent or guardian of a scholar, the equivalent of the first parent-governor. The managers had warmed to Mr Driver at an early stage, recognising his ability, dedication and innate sense of fair play. This had led him in 1919 to offer to increase the rent he paid for the schoolhouse from £9 to £12 per annum. By 1924 this had risen to £16, but again Mr Driver voluntarily raised his payment to £20.

The managers were proud of the school's achievements – the glowing reports from the inspectors were often reproduced in the parish magazine – and often at their monthly meetings they would celebrate the success of former pupils. They had previously followed the successful career of Gilbert Probert, who left the school in 1923, and by 1932 they noted awards and promotions he had won in

his employment as a GPO engineer. At the same meeting, they were pleased to note that former pupil Fred Herbert had won a place at Durham University and another, Jack Postings, was doing very well at a large poultry farm near Torquay where 12,000 chicks had been hatched that year. When Gilbert Probert won a further distinction in 1933, the school was given a half-day holiday to celebrate the award. The whole village rejoiced in success, and there was not a household that did not have useful contact with Mr Driver through his work at the school, in the clubs, in sport or in the church.

In 1934 five pupils won scholarships to grammar schools, bringing the total of Mr Driver's successful scholarship candidates since 1919 to forty-two. In that year, the HMI inspection report noted that 'the headmaster has lost none of his established skill and the staff … support him loyally. The keenness, zest and intelligence of the children, their grasp of what they study, and their whole-hearted response and success in oral and written tests give proof of the headmaster's skill in training them and directing his staff.' When the Board of Education organised another major exhibition, to run alongside the World Education Congress at Oxford in 1935, the inspectors asked Maisemore Church of England School to supply an exhibit. The Congress was attended by 1,500 delegates from all over the world, and one of the main topics for discussion was 'rural life and education'. As the school had already had a fair number of international visitors, the pupils' achievements were clearly of interest. Among the thousands of exhibits were a wooden model of a piggery, a bee-keeping observation hive and an incubator. Perhaps one of those was Maisemore's contribution.

It is worth noting that even though Mr Driver was already using modern teaching methods, he always wanted to be up to date with any educational development that would benefit the children. Therefore, in 1931 Miss Poole and Miss Lacey attended a two-day 'refresher course' at Cheltenham Training College and regularly went to demonstrations of needlework and physical education to improve their ability to teach those subjects. Although there were regular visits from the Poultry Inspector, the Rural Studies Organiser and a bee expert, Mr Driver gave a lot of the instruction in the gardens and with the livestock himself. His ex-pupils all agree that he was very knowledgeable. Ken Cole, who was the son of Alfred Cole (head herdsman at Maisemore Park) and had himself grown up around animals, confirmed that Mr Driver would show the children what to do and 'we cottoned on pretty quick, as we were all country children'. This was demonstrated clearly by poems written by the children about aspects of their lives, as in this extract:

Harvest time by E Charles

When the hay-making is done
Then the harvest has begun,

But if you are a boy or a lad
You lead the horses for your Dad.

When a field is nearly done
Then the rabbits begin to run.
This is the time we have the fun
When a man shoots them with his gun.

I take my father's tea for him,
And we eat our meal together.
We sit beside old Jack and Jim,
These horses are our leaders.

We have fun till late at night,
When I wish everyone goodnight;
I'd rather do what Granny said,
'Up the stairs and into bed'.

Encouraged by the enthusiasm of the pupils in poultry-rearing, one of the managers, Mr H. Stephens, presented the school Poultry Club with an incubator in 1935, and from then on the numbers cared for grew substantially, until there were about 200 laying hens in the poultry shed. Help with the bees was also given by some former pupils, particularly the Hiam brothers, who came in the evenings and at weekends to tend the hives and give advice. Another helper, though not from the community, was William Pymont. He was the County Rural Studies Organiser, and could therefore be expected to have involvement in the school, but he took such a keen interest in Maisemore that he was there frequently, sometimes after school hours, to give demonstrations on pruning, planting and budding, along with guidance on the bees, and quite often he gave lantern slide shows in the evenings to the Pig and Poultry Club. He told the school managers in 1935 that Maisemore School was still ahead of all others in the county in rural subjects. Sadly, Mr Pymont died suddenly and unexpectedly in early 1937 when he was only thirty-nine, just a few days after visiting the school to discuss establishing a plum orchard.

Music, Plays and Poetry

Music and drama also featured strongly in the life of the school. Mr Driver, a member of the church choir, was keen to share his love of music with the pupils. In 1929 he had at last acquired a piano, having raised the funds himself by organising community events such as whist drives. There were regular concerts for the parents, in addition to the usual display of dancing and songs every Empire

Day. Regularly at Christmas the children visited the almshouses in Westgate Street, Gloucester, to give a concert to the residents. And every year the pupils put on little plays or sketches, sometimes at the Vicarage Garden Party or at Maisemore Park, courtesy of the Cridlans, often at the prize-giving. One production fondly recalled by ex-pupils was *A Midsummer Night's Dream* in 1934. Mr and Mrs Cridlan were generous supporters of the school's efforts. In addition to the money they donated each year for book prizes, they hosted the annual treat and Christmas celebrations for the children. Several former pupils vividly recall the treat provided to celebrate King George V's Silver Jubilee in 1935. Mrs Cridlan displayed her 'dress of a hundred pockets', a variant form of Lucky Dip, which they all thought was great fun. To celebrate the coronation of George VI in 1937, the pupils had a day's holiday and each was presented with a beaker and a medal by Mrs Cridlan and Mr Barnes. The regular speech days and prize-givings continued, with the list of prizes ever expanding to include pig-keeping, bee-keeping and poultry care.

Over the years Mr Driver had been offered the chance to move to a bigger school. No doubt Mr Household was keen for him to work his magic elsewhere, and Mrs Driver would have been happy to return to a town, as she had unexpectedly found herself more or less back on a farm, but Mr Driver had no wish to leave Maisemore. However, 1937 saw the end of the tight community of three staff who had been running the school since 1923, when Jenny Lacey left to get married. She had been greatly loved by the children and had vindicated Mr Driver's early belief in her ability when he had first arranged for her to be a pupil teacher. Fortunately she was replaced by Miss A. M. Vosper, who was very

Former pupils remember acting in this production of *A Midsummer Night's Dream, c.* 1936.

Maisemore Park was decorated for King George V's Silver Jubilee in 1935.

well liked by all the pupils. A few months later the school lost another stalwart with the death of Mr Horace Barnes, who had been one of the most dedicated of Mr Driver's supporters. He was much loved by pupils at the school and he had visited regularly until his death in November 1937, aged eighty-six. Mr Driver recorded the great loss felt by the school: 'Mr Barnes rendered wholehearted assistance in all branches of school life and well merited his title of "The Children's Friend".' Mr Barnes' son, Captain Barnes continued to visit the school when possible, and the following year presented a portrait of his father to the school. The pupils wrote delightful poems as a tribute to Mr Barnes, such as the following by 'D.P.':

> Maisemore has lost her 'Grand Old Man',
> His life's work is at an end.
> Though known afar as a sportsman,
> To us he was loved as a friend.
>
> He went to Church each Sunday
> To morning and evening prayer –
> No matter what the weather
> You would always find him there.
>
> At the School he was always welcome
> And there he would often stray –
> A word of praise for work well done
> And encouragement in our play.

He was always a prominent figure
In each branch of village sport.
And his energy and vigour
Was well known on the tennis court.

He's taking now his well-earned rest –
We knew that we must part,
But we shall miss his helping hand,
His kind and generous heart.

We must not grieve – for he had lived
Beyond life's normal span,
And we always will remember him
As Maisemore's Grand Old Man.

Creative writing was very much encouraged by Mr Driver. Just as he had led the pupils to success in vegetable and poultry shows, he put forward the children's work, when appropriate, for external competitions, with a fair degree of success. As early as 1921 an article written by a pupil, Isabel Ibbotson, appeared in an edition of the magazine *The Teacher's World*. In 1925 Cyril Gough won a prize in the national essay competition run by the Lifeboat Institution open to scholars under the age of sixteen. In 1937 Enid Rushforth won a prize in a national writing competition and in the same year the logbook recorded 'Many prizes in the Ovaltine competition', probably for handwriting. This was followed by successes in a *Daily Herald* writing competition in 1939 when four pupils won prizes. On a local level, in 1942 Arthur Cole won a prize from the parish for an essay on 'Why we go to Church'. All this was done in the spirit of the PNEU system, in which children were encouraged to regard examinations more as an exhibition of what they could do, rather than a test of their strengths and weaknesses. Therefore the 'competition' element was of much less importance than the opportunity to offer creative work to a wider audience.

Poetry writing was a regular activity, and some of the poems which Mr Driver preserved, handwritten by the pupils in a book, show a sense of fun and a whimsical look at life. For example:

The New Shoes by Jessie Green

New shoes are always risky,
As you will all agree
But if you don't, I'll tell you
Just what they did to me.

The New Shoes.

New shoes are always risky,
As you will all agree
But if you don't. I'll tell you
Just what they did to me

To save them from a puddle
Across I tried to leap,
My shoes came down too early,
And oh! that mud was deep

I wiped them with my hankie,
To make them spick and span,
And fearing further mishap,
Straight off to school I ran,

But Billy had a football,
My shoes were overjoyed
They squeaked and ran to kick it.
Tho' I was most annoyed

And when a little later,
The school bell rang, I tried,
To make them smarter looking,
Before we marched inside.

My teacher eyed me sadly,
And said: "Where have you been,
To get yourself in that state?
I'll teach you to be clean".

 Jessie Green,
 19 . 7 . 81

'The New Shoes', in the young poet's handwriting, was preserved in a book of poems kept by Mr Driver.

To save them from a puddle
Across I tried to leap.
My shoes came down too early,
And oh! that mud was deep.

I wiped them with my hankie,
To make them spick and span,
And fearing further mishap,
Straight off to school I ran.

But Billy had a football,
My shoes were overjoyed
They squeaked and ran to kick it,
Tho' I was most annoyed.

And when a little later,
The school bell rang, I tried
To make them smarter-looking
Before we marched inside.

My teacher eyed me sadly,
And said: 'Where have you been,
To get yourself in that state?
I'll teach you to be clean.'

Dirty shoes seemed to be one of Mr Driver's pet hates and stirred up a different memory for some pupils. Two brothers told their families in later years how they were frequently ridiculed by Mr Driver for arriving with very muddy boots, after working before school on the family smallholding. If Mr Driver was so keen on clean shoes, one wonders what happened to the boys who helped muck out the school pigs.

Rural Studies Go from Strength to Strength

In 1938, HM Inspector L. S. Wood wrote:

This school well maintains its excellent tradition. It continues to be a happy and vigorous community which derives its main inspiration from its own environment. The head master has given many years of devoted and enlightened service to the village and the results of his work are most gratifying. Because the major activities of the school are vital and essentially practical, the children

show keenness, energy, enterprise and skill which are striking. The scientific and businesslike way in which the keeping of bees, poultry and pigs is conducted is admirable, and the records and other written work in connection with these activities are very good. The children are quick to grasp what they study and they talk intelligently. The development of originality is fostered in a skilful way: the school magazine, for example, affords ample proof of this.

From this it can be seen that in the inspector's view, the rural success was dominant. Academically, the school also did well, but the rural studies were extensive and varied, and about to become even more significant with the outbreak of the Second World War.

The report in the 1938 *Maisemorian* confirms the pupils' business understanding and their awareness of profit and loss. They summarise the successes – and failures – of the work in the gardens and with the poultry, pigs and bees. Pupils remember particularly that there was a special fertiliser that they put on the onions to great effect. (There were no rabbits at that time, but they were re-introduced later.)

The gardens have done very well this year. As usual the brassica family – cabbage, broccoli, cauliflower, etc. – led the way. Early potatoes proved a paying proposition: we must grow more next year. Onions were well up to the standard, many being 17" round and weighing 3 lb. Salads did well, especially the Trocadero lettuce. Celery was good, but the leeks and beet ran to seed. Roots were weak: we must thin more. Broad beans gave a good result, also runner beans and peas. At the Show we won seven prizes with seven exhibits. Our expenses came to £5 0s 6d and income £22 18s 9d, the balance being £17 18s 3d.

The bees provided much interest during the year. One stock swarmed, but as the queen was four years old, we allowed them to go. After giving each stock a good supply of food, we packed them down for the winter. 80 lb of honey was taken, for which we received £5. The expenses were £3 2s 6d and the balance £1 17s 6d.

In spite of disaster when we lost 3 pigs through erysipelas [an infectious disease], we stuck to it and came up smiling. We have erected a new cot with concrete floor lined with planks and rubbing boards. We also made them a large run. The pigs loved it and did well, turning a deficit into a profit. We are grateful to Mr Luker and our numerous friends. [Mr Luker was Mrs Driver's father, a retired butcher and farmer in Stroud.]

Although the above achievements are impressive, it is the poultry-keeping which sees the children handling large sums of money:

A great fight against disease is a summary of the year's work in the poultry run. 15,734 eggs were laid by 120 birds, the receipts being £100 5s 1d and expenses £87

19*s* 4*d*, the profit being £12 5*s* 9*d*. We also won First prize with brown eggs for the first time. The RIR [Rhode Island Red] and BL [Black Leghorn] cross was not a success and we are returning to our former cross, RIR and LS [Light Sussex].

In 1938 the girls were dealing with 120 hens, over 15,000 eggs and a turnover of £100, which was a huge sum of money for the children. Yet they coped without any prompting. First thing in the morning, the girls would clean out the trays in the poultry shed and feed the hens. Then at lunchtime they would collect the eggs and feed the hens, and again before they left school in the evening. Every egg was washed, then stored ready for the 'egg lorry' that called to collect the eggs once a week. Many of the villagers kept chickens by now, thanks to the Pig and Poultry Club, and some had surplus eggs to sell. They would take these to Mr Driver at the schoolhouse in the evening; he would log the quantity, put them in with the school collection, and give the villagers the money due when the school received payment.

So, apart from his work at the school – teaching classes, supervising the rural studies, giving guidance to the staff, taking the pupils to agricultural shows or theatre performances, arranging school trips, dealing with the Board of Education on relevant matters – Mr Driver's 'free time' was utilised to the full, all for the benefit of the village: secretary to the football club and cricket club, member of the church choir and the parish council, organiser of the Coal Club, the Clothing Club and the Pig and Poultry Club, which involved taking orders and weighing out deliveries of seed, seed potatoes, fertiliser and meal and then arranging delivery to the villagers and sending out invoices, and now he was intermediary in egg sales, accepting eggs at his home in the evening. He was also the local organiser for the National Savings Scheme, and as war drew near he became a Special Constable and was soon superintendent of the four constables in the village. It is hard to comprehend how he found the time.

In December 1938 the school lost another good friend and loyal supporter with the death of Mr J. J. Cridlan. This was a great loss to the community, the school and Mr Driver personally, as they had forged a strong working relationship based on mutual respect and their shared principles and standards. Although Mr Driver was not one of the school managers, Mr Cridlan had always involved him in important decisions about the school. Fortunately the managers continued this tradition, and invited Mr Driver to participate when they were considering a new teacher appointment.

The managers had been forced to act rapidly in 1938 when the Rural District Council visited the school and condemned the lavatories. Remedial work was essential. After some urgent fundraising and help from local charities and the Diocese, flush lavatories were installed at the school at a cost of £200. The pupils recorded in that year's *Maisemorian*: 'New lavatories, and modern ones too, have been erected, also wash basins. This has certainly made the school a much happier

place.' This was followed by repairs to the roof and the stove. Problems with the fabric of the building and the heating or lack of heating were continuous, but Mr Driver, his staff and the pupils just got on with things. And still the visitors came, to observe PNEU method and/or rural studies. The magazine was still published annually, and that year its account of Speech Day lists thirty-four separate prizes awarded to thirty individuals, (about half the school) in subjects that well illustrate the breadth of the education at Maisemore: Scripture, English, arithmetic, history, geography, science, art, music, needlework, rural subjects, physical exercises, 'merit', and 'general improvement', together with neatness, manners and kindness. And the editor's notes concluded: 'To our Prime Minister, I say on behalf of all, Thank you Sir! for saving us from the greatest of all horrors – War.' Clearly the pupils were aware of current events in the outside world. Unfortunately, they, and the Prime Minister, were mistaken.

The Second World War
Rising to the Challenge

The year 1939 began with serious flooding of the River Severn. Flooding is not uncommon in the area, but it must have been particularly bad to merit mention in the logbook. Many children could not get to school and attendance was further depleted by illness. But as things got back to normal, school life continued in the usual vein. The annual trip was to Cheddar and Weston and former pupils remember the coaches lined up outside the council houses in the village: a small soft-top, 'ramshackle' one for the infants, a bigger one for Mr Driver and the other pupils, and two coaches for the parents and friends of the school. At least one former pupil recalls that Mr Driver and his son, by now at university but home for the holidays, entertained the children on the bus on the way home with a bit of slapstick comedy.

Two pupils won scholarships, H. Williams to Newent Grammar School and R. G. Hale to Rendcomb College. Rudolph (Rudy) Hale, now known as Gordon, first met Boss Driver in 1936 when he moved from Hartpury to Maisemore with his father and sister after the death of his mother in 1935. His father had attended Maisemore School in the early days of Mr Driver's headmastership, and was one of the pupils responsible for starting up the garden. Gordon was an able pupil, and Mr Driver put him forward as a candidate for a Foundation Scholarship at Rendcomb College, near Cirencester, a boarding school, instead of the more usual grammar schools in Gloucester. Gordon, a retired Army major, recalls:

[For the scholarship] I had to study very hard under Boss Driver's guidance. He was a superb teacher, but an extremely strict disciplinarian. [After the examination] I remember the headmaster of Rendcomb, D. W. Lee-Browne, and his senior master, J. C. James, arriving at our cottage in the Old Road in Mr Lee-Browne's open green Bentley. I then drove with them to the school to meet Boss

Driver, who was busy in the garden. I spent some time showing them round and I am sure they must have been very impressed with what they saw and heard. Their visit was followed by a day's interviewing in the Shire Hall and eventually the news that I was one of the four [county-wide] successful applicants.

The school year ended with Speech Day, prior to closing for the summer holidays on 4 August.

The next logbook entry heralds a big change: 'School did not re-open until September 11 due to outbreak of war. Woodwork classes have ceased for the present. Extra time being given to gardening'. That last comment shows that Mr Driver realised at once the importance of home-grown produce during a war. He had assumed the headship of Maisemore Church of England School in the middle of the First World War, and had started gardening at that time to counter food shortages. This time round, gardening was well established and potentially could be increased. In the village, Mr Driver was closely involved with the success of the many village allotments, providing seed and fertiliser supplies through the Pig and Poultry Club. The obvious thing was to increase food production at the school as well. Mr Driver asked Mr Chamberlayne of Maisemore Court Farm, the school's neighbour, if the school could have some extra land, and as a result the pupils were able to grow additional potatoes. They worked half an acre and produced amazing quantities, no doubt helped by the ready access to the free manure still available to them on the farm.

The children's own summary of their work in the 1940 edition of the *Maisemorian* is as matter-of-fact as usual, but is really quite astounding. The title of the article is 'On the Farm', rather than 'In the Garden/poultry shed/piggery' as previously, and clearly reflects the increase in the scale of production:

> Owing to the war we took in and cultivated extra land, the potato crop from which was quite good. In spite of a severe drought the majority of the crops did well, the following being a rough estimate of what our half an acre produced:
>
> Broad beans 2 cwt, runner beans 5 cwt, potatoes 20 cwt, roots 10 cwt, onions 3 cwt, peas 1½ cwt, marrows – 100, cabbage and savoy – 1,000, cauliflowers – 500, tomatoes ½ cwt, and a large quantity of salads.
>
> All vacant land has been dug and manured, about 500 spring cabbage plants put out and a large area sown with broad beans. In 1941 we intend to make two crops grow where one grew before.

Similarly, the school enlarged the piggery. They bought ten small stores in March 1940 and fattened them up until they were able to provide 160 lb of bacon. The profit from this, over £12, went towards erecting a new run with a concrete floor and a furnace, so that they could boil up a much greater quantity of salvage for feed. Tom Hathaway recalls that the boys used to clean out the pigs every morning

ON. THE. FARM.

I am pleased to report a record year. Owing to the war we took in and cultivated extra land the potato crop from which was quite good.

In spite of a severe drought the majority of the crops did well the following being a rough estimate of what our half an acre produced: B. Beans 2 cwt., R. Beans 5 cwt., Potatoes 20 cwt., Roots 10 cwt., Onions 3 cwt., Peas 1½ cwt., Marrows 100, Cabbage and Savoy 1,000, Cauliflowers 500, Tomatoes ½ cwt., and a large quantity of Salads.

All vacant land has been dug and manured, about 500 spring cabbage plants put out and a large area sown with broad beans. In 1941 we intend to make two crops grow where one grew before.

Our expenditure amounted to £7. 0s. 10d. and the income £25. 1¼s. 7d. the balance being £18. 13s. 9d.

We had quite a successful year with the Bees. We took 180 lb. of honey. They looked a busy family when working in the sunshine. Only one swarm

Although the pupils wrote the articles, Mr Driver copied out every edition of the *Maisemorian* in this script for publication.

before school and put in fresh bedding. Then he would light the furnace to boil up the scraps collected around the village. He had permission from Mr Driver to miss the first lesson, Scripture, if he had too much to do, but woe betide him if he was not back in the classroom in time for the next lesson, arithmetic. As for the bees, they were thriving and supplied 180 lb of honey. The school bought an additional hive and planned to increase the number of stocks to four. All these enterprises provided excellent quantities of produce and a healthy profit, with money going to the children eventually through the annual payout.

As usual, the poultry shed produced a huge number of eggs:

This year the fowls have done quite well when the food difficulty and the severe winter are taken into account. As announced last year, we have raised our flock to 120 birds, all this year's pullets, and a RIR and LS cross. We also fattened 50 cockerels; they weighed about 5 lb each and gave a fair return. The birds appear to be very healthy and all traces of disease seem to have disappeared. 10,184 eggs had been laid by the end of November, which averaged 180 eggs per bird per annum. During 1941 we intend to buy 50 heavy breed day-old cockerels in January and 100 day-old pullets, RIR and LS, in March. Using up all scraps etc., we hope to be able to carry on successfully. We spent £100 4s and received £109 10s 4d, the balance being £9 6s 4d, which is good when the raising of the flock is taken into consideration.

The above extract from the *Maisemorian* shows that the pupils thoroughly understood the logic of investing the profit to achieve greater yields in the future.

These achievements attracted the attention of the press, always keen to promote a good, heart-warming story to boost spirits in wartime. Local photographers were followed by some from the national press who visited in July 1940, and newspapers published articles with predictable titles such as 'Digging for Victory'. And still the visitors came, including Heads of Rural Studies from other counties who wanted to replicate the success of Maisemore in their own areas.

PNEU and 'The War Poets'

Despite all this activity outdoors, Mr Driver continued to teach a full academic curriculum and maintained the high standards achieved in PNEU examinations. Although Charlotte Mason had long since died, her work continued. The books continued to arrive from Ambleside, and there were examinations set and marked twice a year. The pupils gained good marks and appeared to relish the wide range of subjects offered. In 1938 the editor of the *Maisemorian*, which by this time had acquired an attractive new cover, commented that 'the [PNEU] programmes of work have been most interesting, especially geography, science and literature'

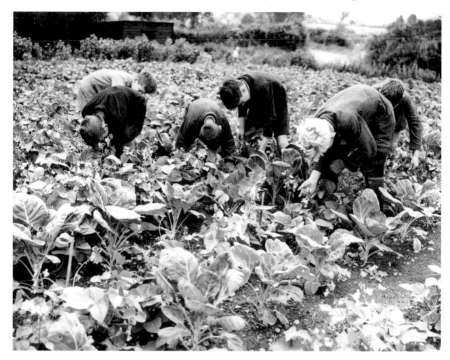

This and the following four images formed part of a series of press photographs taken on 12 July 1940. Here boys are tending cabbages.

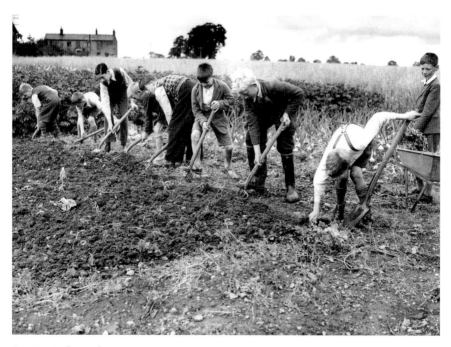

Digging in the gardens.

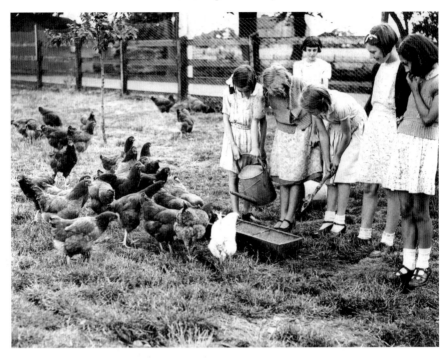

Girls with a few of the 150 or so chickens at the school.

Marching back to school after gardening.

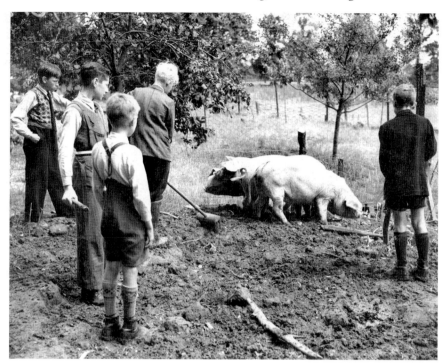

Caring for the pigs.

(though of course those choices reflect the interests of the pupil editor). Several ex-pupils have commented that they cannot remember anyone ever failing an examination.

The wartime editions of the *Maisemorian* always included a brief comment about progress in the PNEU syllabus:

1939 PNEU was greatly enjoyed.

1940 PNEU programmes were most interesting, the work enjoyed and
 the examination results good.

1942 PNEU programmes were greatly enjoyed, the books chosen being
 most interesting and the examinations results good. The library with
 its variety of books was well patronised.

This last comment is particularly interesting: the pupils were very fortunate to have a ready supply of reading material. By the middle of the war there was a serious paper shortage, and little was being printed. The *Maisemorian* of that year was only half its normal size, and in fact it turned out to be the last edition published. Some of the writing may occasionally sound rather stilted or even pompous, but this is the effect of young pupils trying to sound grown up – and

The cover for the *Maisemorian* has been redesigned with an attractive drawing of the school.

through the PNEU syllabus they had been exposed to a wide vocabulary and adult ideas.

The PNEU organisation had its own inspectors who called in at schools, usually without warning, to see how they were getting on. Presumably the inspectors did not wish staff to go to any trouble for them, but this also meant some wasted journeys. One Gloucestershire school was visited on the day of the County Scholarship examination, so the inspector rightly thought it inappropriate to go in. And on 9 September 1942, Miss Elizabeth Molyneux, one of the (exclusively female) PNEU inspectors, called at Maisemore Church of England School. She wrote, 'I was lucky enough to meet Mr Driver, but his school had been given a holiday for potato-picking. If I come to the neighbourhood again, he has offered me hospitality in his own house for a week, really most kind.'

Creative writing was encouraged and often reflected local events. For many years, Mr Driver had been keeping a record of some of the best poetry by the pupils, which they themselves had copied into a book. To these were added a wide variety of poems about different aspects of the war. The school windows were fitted with blackout material and 'Net' to protect against bomb blast and the vicar made available the vicarage cellar for use as an air raid shelter if required. In the event of an air raid in school hours, this would have been most useful as the vicarage was the nearest building to the school, but both were some distance from the rest of the village. The children also practised sheltering against an earthen bank near the school as a protection from bombers if the pupils happened to be caught out of doors. A former pupil who was an infant at the time recalls lying against the earth and thinking 'What happens if the Germans come from the other direction?' By 1941 the children had gas mask practices three times a week. Air raids sometimes caused the children to be late for school and it all became very real for the children when, in November 1940 while on their way to a fundraising whist drive with their parents, they saw German bombers following the line of the River Severn as they flew northwards on what became the Coventry Blitz. The glow from the burning city could be seen from high points in Maisemore. The following poems were very much of the children's own experience:

The Blackout by Beaty Wadley

Law is law, we must abide it,
From dawn to dusk, morn till night.
Everyone must do his duty
To help our country through this fight.

In the house, no air at all
Except for draughts from door and hall,
Great thick curtains wrap windows about
To stop the light from shining out.

Cycles and cars, their lights are dimmed,
In the street no lamps are trimmed;
Policemen are roaming around and about
To see Blackout Laws are carried out.

The Fire watcher by T. P.

All through the long and dreary night
The watchers are quite near
To quickly give us warning
If danger should appear.

Should guns boom out at planes o'erhead
I do not mind a jot
Because I know the watchers
Are always on the spot.

If bombs should fall around them
Their duty they don't shirk.
They think not of their safety
But bravely do their work.

And when the war is over
And victory is won,
We'll all be very proud to say
"You did your part. Well done!"

The Specials by Pamela Postings

Each night while round the fire we sit
Our police are on their beat,
Scanning all the houses
Up and down the village street.
Should you neglect a window
You will hear his stern voice shout
'Your blackout is imperfect
And the enemy is about!'

No matter what the weather be,
He always does his best.

And when his help is needed
He never thinks of rest.
Though guns may roar and bombs may fall
From 'Jerrys' overhead,
He does not mind the danger
When we are tucked in bed.

Mr Driver had volunteered to be a Special Constable as soon as they were required. He was always in the forefront of anything to benefit the community and he soon became the superintendent or section officer of the four constables in the village, who included Bill Price, Bill Powell and Alfred Cole, exempt from war service as they were key workers in agriculture, which was vital to the nation. A former pupil, Tom Hathaway, recalls cycling home in the dark, with no lights of course because of the blackout, when someone suddenly stood out in front of his bike. It was Mr Driver in his role as Special Constable, checking the lanes. Tom had by then left the school and gone to grammar school, but Mr Driver immediately recognised him: 'Be careful now, Thomas. Off you go.'

Although farming was a reserved occupation, many farm workers had volunteered and the labour force was greatly reduced. Later in the war, Maisemore residents

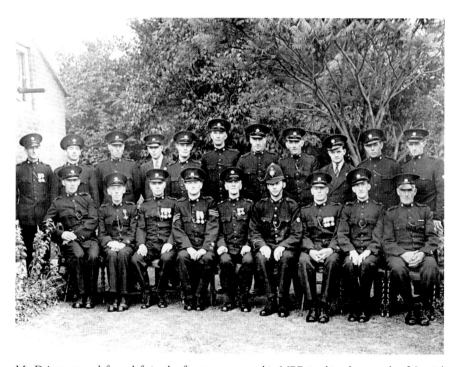

Mr Driver, second from left in the front row, wears his MBE in this photograph of Special Constables.

recall seeing German and Italian prisoners of war working in the farm fields, and throughout the war schoolchildren in many rural areas helped plant potatoes for the local farms. In 1941 Mr Driver noted that the top class dropped one ton of seed potatoes at Rectory Farm in one hour 15 minutes and later picked 25 tons for local farmers. The following year they planted 10 tons of potatoes for the farmers and that autumn picked 120 tons. Although this was almost all in a day's work for the Maisemore children, some former pupils recall that it was pretty strenuous activity. One girl who was working at Persh Farm – a good mile's walk from the school – recalls asking the farmer a question. He responded curtly, 'You're not here to ask questions, get on with your potato-picking.' Nearly seventy years later, she cannot remember the question, but clearly remembers the reply. She was probably all the more offended as she was used to hard work in the school garden and with the chickens; there, relevant questions were encouraged, and politeness earned a response. As long ago as 1931, a farmer had commented on the way an ex-pupil, now his employee, had asked endless questions, but he rightly took it as the sign of an enquiring mind and a desire to learn.

Early 1941 saw heavy snowfalls and then severe flooding, during which time some children boated to school. As the school was quite a long way from the river, the flooding nearer the river must have been dramatic. There were also some notable events:

- At long last, a tank was installed by the Ecclesiastical Commissioners to ensure a sufficient water supply.
- Miss Ivy Hooper, who in 1940 had taken over from Miss Vosper, married in June, becoming Mrs Jones, and for the first time a married woman was able to stay on at the school as a teacher.
- All the pupils were immunised against diphtheria, the first time such immunisation was available.

There was the usual success at the scholarship examinations when two girls won places at Gloucester High School. A third pupil, Doreen Whitmore, won a scholarship to the School of Art in Gloucester. She had been ill at the time of the previous year's scholarship exams and, it would seem, had missed her chance. She had therefore stayed on at Maisemore, but Mr Driver did not want an able pupil to miss out on further education. As she was a talented artist, he suggested that she apply for the School of Art and she was successful. Yet again, Mr Driver's personal interest in the progress of his pupils had led to an opportunity that might otherwise have been missed.

Doreen's 'extra' year at Maisemore School meant that she and her friends could continue looking after the chickens. An outsider who heard that the school kept chickens might imagine five or six hens fussed over by little girls, but nothing could be further from the truth. The large poultry shed, 21 feet by 18 feet by 15 feet,

could house 200 birds and it had always been run as a business. The production of eggs became even more significant in wartime as a contribution to Britain's food supplies. Hygiene was of the greatest importance, for the health of the poultry and of the pupils, so the bird trays were scraped and washed every morning, and there were rarely losses through disease. Pupils recall carefully adding dark red 'potash of permanganate' crystals (potassium permanganate) to the chickens' drinking water in winter, which was an old remedy for curing and preventing diarrhoea. A solution of the crystals could also be used as a disinfectant. It should be remembered that water was only laid on to the school in 1938, and only in 1941 was there the prospect of an adequate water supply. Yet the poultry shed was kept clean, and every egg was washed in the evening before they were stacked in boxes for collection. The new water supply was a great boon for the garden as well: Doreen recalled that previously, although the girls did not do much gardening apart from some weeding, in hot weather they had the job of carrying water to big tubs for use on the plants. It was easier to collect water from a tap than from the pump.

During the First World War, Mr Driver had encouraged the children in fundraising efforts for the troops, and between the wars they had been active in raising donations for various good causes, such as charities for the blind, the Children's Hospital or Earl Haig's Fund. As early as 1925 Mr Driver had started a National Savings Scheme for the pupils, following on from the War Savings effort of the First World War, and according to the 1938 edition of the *Maisemorian*, by that year the National Savings at the school amounted to £896 2s 6d. Children and their families contributed, and many invested the cash bonuses that they received at the end of each year as their share of the profit from the gardening/poultry/bees/pigs. Fundraising took on a new dimension in wartime. Efforts were redoubled with great success, and it was no surprise when they organised a 'War Weapons' Week in November 1940 and raised £615 5s 0d. Regular savings schemes continued, and some of the pupils gained awards for their individual efforts in raising very large amounts. The War Savings Association started by the school in 1939 with an initial twenty members achieved a dramatic increase in membership to ninety by 1940, and that year the savings totalled £1,982 16s 0d.

Fundraising continued in 1941 with £509 raised for Machine Gun Week and £275 for Warship Week. The total in War Savings raised that year was £1,360 but, they wrote, 'We must do better in 1942.' Indeed they did, for in 1942 the total achieved was £1,525. These sums were highly creditable in a small rural area of no particular wealth, yet in addition to the war effort, the pupils continued to contribute to other charities, and even made donations to the Red Cross from the Rural Club bonus. In the 1942 *Maisemorian*, the editor wrote, 'Collections during the year for deserving charities were well-supported: it is our duty to help those who are handicapped in life.' This concept of duty and service to others had been instilled in all the pupils by Mr Driver who, by his quiet faith and determination

in and out of school, provided a strong role model. In fact, unusually for that time, the school timetable included a weekly lesson on 'Citizenship' which stressed the concept of duty, fairness and respect for others. This also linked with the favourite PNEU maxim, 'I am, I can, I ought, I will', which could serve as a description of the philosophy that guided Mr Driver's own actions.

The children were also quick to acknowledge assistance, to thank the helpers and benefactors of the school, and to congratulate fellow pupils and other members of the community on any success. In the *Maisemorian* of 1940 the pupils rather touchingly wrote, 'Congratulations to Major Barnes on his well-earned promotion'. Captain Barnes, son of the late Mr Horace Barnes, had become a good friend to the school. In the same edition, the pupils also congratulated 'A. Driver on being our first BSc'; this was Alfred Driver, son of their teacher, who had graduated from Bristol University. In the magazine there are reports each year of Speech Day, with careful mention of all who contributed and thanks to the donors of awards. By 1941, the war had disrupted the social events for the school in that the holiday dates were changed and the school outing and external trips had to be cancelled, but home-grown entertainment flourished. The pupils put on a play most years, and Mrs Driver, who was rarely directly involved in school activities, helped with costumes and make-up. On Speech Day in 1941 the pupils offered a concert to family and friends with a short play, songs and readings of the pupils' own poems. The war was in their thoughts, but although much of the poetry written in school in the war years concentrates on the Armed Forces, some took a slightly different angle:

Summer by A. Mason

We love the months of summer,
It makes us bright and gay,
Especially when we can help
The farmers with their hay.

We look out through our windows
At the bright and peaceful morn,
Not thinking or realising
The battle of the storm.

One day the war will be over,
We pray it will be soon.
Then our gallant men will come home again
And enjoy the summer too.

Home by P. Hale

Our little house needs rugs of blue
To lie upon its floors.
New curtains, and some covers too,
Bright paint on shabby walls.

Till war is done we still shall lack
These lovely furnishings
But darling heart, when you come back
We shall not miss these little things.

You'll smile into my eyes and I
Shall hold you close, no more to part,
With nothing left, with which to sigh,
Since home is here within thy heart.

But one of the younger pupils lightened the tone and summed things up:

Maisemore School by P. G.

Maisemore School is very good.
We help to grow a lot of food.
We keep poultry, pigs and bees
And in the fowls' run are fruit trees.

The gardens have produced large crops
Many pounds of honey were obtained from our stocks.
The fowls are laying very well
And the pigs look healthy on their swill.

Feeding the Nation

The pigs were indeed healthy, all twenty-two of them. They were fattened up mostly on salvage and they thrived, eventually providing one and a half tons of bacon. Unfortunately an unspecified 'foreign substance' in the salvage caused the untimely death of one animal, but the pupils were able to get some compensation through the Pig Club. Despite food shortages, the poultry were also a success. The pupils fed them on three-quarters salvage and one-quarter mash morning and evening, with a little corn at midday. They wrote:

In February we raised 50 cockerels and made a good profit on them. During March 100 LS [Light Sussex] and RIR [Rhode Island Red] pullets were hatched: these are now laying. Next year we hope to purchase 75 RIR + BL pullets. Our birds have layed [*sic*] 13,858 eggs, the income being £184 13*s* 1*d* and the expenditure £117 12*s* 1*d*, the balance £67 1*s*.

A food shortage of a different kind affected one of the other enterprises: one of the stocks of bees died in April through starvation. This did not reflect badly on the pupils' standard of care, as they did the same work as adult beekeepers. They had no doubt checked on the queen bee and bedded the hive down in September, putting in about three gallons of liquid feed to keep the bees going through the winter, but if there is a mild winter – which makes the bees more active, using up more food – or a late spring, the bees can run out of food before they can replenish their supply. Never sentimental, the pupils cleaned out the hive and fitted it up again. A few weeks later a strong swarm settled in and did well. Despite the loss of the first stock, the pupils collected 1 cwt of honey and made a profit of £8 12*s* 6*d*.

Good results were also achieved in the vegetable plot:

> This year has been an excellent one for gardening and our crops did well, especially the broccoli, beans, potatoes and roots. The onions for the first time failed; this was caused by bringing up subsoil and a too heavy dressing of chemicals. The potatoes were a good size and free from disease and pests with the exception of Doon Star which the slugs attacked. We had a heavy crop of tomatoes which it was difficult to ripen and also some ridge cucumbers. Peas and marrows were quite satisfactory. We are now busy digging and manuring every inch of spare land and hope to raise a much larger supply of food next year. The income was £30 17*s* 7*d*, the expenditure £14 5*s* and the balance £16 12*s* 7*d*.

All this made for a record year for the Rural Club, with a bonus of £30 to be shared among the pupils. It should be remembered that, in addition to the above, the older pupils helped out local farmers with the potato crops. There was never a dull moment.

In 1942 the school's pig-rearing was very successful. Fifteen stores were fattened, which resulted in about one and a half tons of bacon. They were fed chiefly on salvage collected from the village, potatoes and a little meal, with added cod-liver oil to keep them in good health. One was slaughtered and salted and kept for the villagers, and all the rest went to the Ministry of Food. It was, however, harder to feed the poultry on salvage scraps, but the pupils did their best. Nevertheless, the food shortages meant that they had to reduce the flock from 150 to 60, of which fifty were pullets (Black Leghorn and RIR cross). That year 10,804 eggs were produced, rather fewer than the 13,800 of the previous year, but they still made a good profit, £27 14*s* 2*d*. The weather – cold spring and wet summer – did not suit the bees, but

they still produced 52 lb of honey. The pupils were clearly worried about the future of the bees over the winter: 'We fed them in September and packed them down for the winter, but the mild weather has caused a heavy drain on their stores and the outlook is very uncertain.'

Results in the garden were good. The potato crop turned out well, 'especially the Majestics and Dunbar Standards', the beetroot crop was excellent, and carrots and parsnips were above the standard. Less successful were the tomatoes, which did not ripen, and the early broad beans, killed by frost, but the later crop of broad beans was good, as were the runner beans, Brussels sprouts and shallots. Not content with this, the children wrote, 'We shall do our best to raise more food in 1943.'

On the academic front, the local area inspectors of HM Inspectorate all enjoyed visiting Maisemore and sometimes dropped in to see Mr Driver and the children without undertaking a full inspection. The pupils were equally enthusiastic about the inspectors, who had become good friends over the years; in 1938 the children wrote that there had been several visits from inspectors 'and the time spent with them was very enjoyable. They were very friendly.' In addition to the HMI inspections, there were inspections by the Diocese, as it was a Church school. These invariably rated the school as very good or excellent. In 1938 Reverend Gethyn Jones visited and stated in his written report:

The general tone is very good. The infants' answers were good and there is a good standard in the Upper and Middle classes. Written work is neatly done. It is a very happy school, the comradeship of pupils and staff made the visit a very happy one.

It should be remembered that discipline was much stricter in schools in those days, and corporal punishment was common. Several pupils have recalled how Mr Driver could fly into rages when annoyed and be very intimidating. While some say simply that he was very strict and punishment would be meted out for misbehaviour, girls who transferred from a city school at age nine were shocked by the violence, verbal and physical, of these outbursts, which were unlike anything they had experienced before. (They were also taken aback by the different age groups in the same class – the norm in country schools – and the old-fashioned premises.) They feared being picked on and 'kept their heads down'. The other pupils were used to the situation and had never known anything different. Several ladies do, however, remember that Mr Driver would sometimes pull them out of their seats by their hair, and one ex-pupil recalls a sister standing up for her brother when Mr Driver gave him a 'clip round the ear'. As a result, she got a clip round the ear too, for answering back. The boys with the muddy boots also felt they were picked on and the focus of many of his tirades. Not everyone was a devoted fan of their teacher. Although such behaviour towards pupils would be unacceptable today, the community in Mr Driver's time expected teachers to be strict; if children ever complained about punishment, their parents, probably former pupils of Mr Driver themselves, tended

to accept that they had probably deserved it. Yet other pupils, while agreeing that Mr Driver could be an ogre in the classroom, clearly remember him striding across the playground with a smile on his face after inspecting the pigs or poultry, swinging his arms and clapping his hands, often humming to himself. Outside the classroom, for example on the sports field, he was usually very friendly. Many of the inspection reports over the years stress the comradeship and general happy atmosphere. This was the overall impression of several different and experienced inspectors who were used to visiting and inspecting a wide variety of schools and should have been able to detect undercurrents of unease.

During the Second World War, the HMI inspections are not recorded, although inspectors called in from time to time. Many of the Inspectorate were in the Forces, and those still in post concentrated on schools in need of guidance to improve performance. The Diocesan inspections continued throughout the war and, as ever, found the school to be very good. The religious instruction is not highlighted in the school logbook, as it is in many Church schools, not because it did not happen, but rather because it was such an essential and integral part of school life that it did not warrant special mention. In 1940 the Reverend Mack inspected and commented that 'the special prayer for the parish recited from memory by the children is worthy of being circulated among and used by every Church School'. In 1941 the Diocesan inspector praised Mr Driver's modern methods and was pleased that the children had access to booklets by the Bible Reading Fellowship.

In November 1941 Canon Billett died, and the school was greatly saddened to lose him. He had been a regular presence at the school, teaching scripture and taking assemblies at least once a week for over twenty-five years. He was much loved by all, and the pupils had particularly enjoyed his Old Testament lessons. He and Mr Driver got on well, and he was sorely missed. His successor, Reverend Malcolm Playfoot, was inducted as vicar of Maisemore in April 1942. One of the pupils, Betty Cole, commemorated the change in part of her poem about Speech Day:

> There is a friend that we all miss,
> He always had a smiling face
> But we all extend a greeting
> To the one who fills his place.

In fact, Reverend Playfoot soon inspired another poem when he organised a working party of villagers to clear the vegetation around a cross lying neglected in the churchyard:

The Churchyard Cross by T. Hathaway

> In Maisemore Churchyard one fine day
> Hidden with ivy, but stout to stay,

> A cross which bore the names of people
> Who passed away beneath its steeple.
>
> Overrun by ivy,
> Hidden from the eye,
> It attracted no one's notice,
> Until our new vicar passed by.

In 1942 the Diocesan inspector wrote, 'This is an unusually good school in which Head Teacher and staff give of their best', and in 1943 Reverend Mack said everything at the school was very good:

> The teaching is presented in a manner which is bright and attractive and adapted to the child mind. It is a great satisfaction to visit this school where the head teacher is so alive to the importance of instilling into his pupils not only the facts concerning the Christian Faith but also a spirit of devotion.

In all this, Mr Driver was backed up by Miss Poole, who showed similar commitment.

In wartime the nation was keen to hear good news, and the BBC sought out locations that would make for an uplifting and enjoyable feature. Maisemore School clearly fitted the bill and in January 1942 a reporter from the BBC visited to find out more about the rural section of the curriculum. This resulted in a radio programme about the rural activities of the school, which was broadcast on 3 February. There was plenty to talk about, and it made for an inspiring programme. Although the school did not have a radio, Canon Billett had been in the habit of bringing one into the school so that the children could join in special services, such as Armistice Day. It is therefore likely that he did so on this occasion, as the broadcast is noted in the school logbook.

Maisemore Keeps Calm and Carries On

The exact details of the school's food production in 1943 are not known, as the *Maisemorian* was no longer published because of the paper shortage, but the pupils continued to help local farmers. In addition to this and amid the production of valuable food for the nation, the school entered exhibits in the Horticultural Show at the Guildhall in Gloucester. They submitted fourteen entries and won sixteen prizes: eleven Firsts, three Seconds, the Silver Cup and Lord Bledisloe's special prize for the best exhibit. This achievement was recorded in the parish magazine. The community continued to be proud of its young workers.

The school logbook that year also records that 'a lesson and demonstration in pig slaughtering was given to the elder boys', but it was not usual to kill the pigs at

the school. Rabbits were now added to the list of livestock. The school continued to enjoy the assistance of committed helpers and advisors, some from the County and some voluntary, particularly Mr Crouch (rabbits), Mr Green (bees) and Mr Nock (poultry). The marketing for all the produce worked well, and in 1943 the Rural Club's profit was £68, of which £40 was distributed as a bonus to the pupils.

Meanwhile, the Pig and Poultry Club in the village continued to flourish. Many of the men were in the Forces, so the wives were tending the pigs, chickens and gardens, and the production of food was very important to the families. Mr Driver ordered feed and supplies and continued to distribute them from the Meal Shed, carefully weighing out the amounts on ancient scales. Pupils sometimes helped with deliveries; one recalls borrowing a horse and cart from a local man and taking the sacks of meal around the village on a Saturday or Sunday morning, perhaps ending up at the pub with the horse's owner, though the boy was about twelve years old at the time. Former pupils also helped out: one lady remembers her courting days when she and her husband-to-be used to ride round the village by horse and cart on a Saturday afternoon, delivering pig meal. Another very athletic girl used to run round delivering invoices to the members of the club. As it is a spread-out village, that was quite an undertaking. The willingness of these and others to assist underlined the strong sense of community that had been instilled in them since schooldays.

Occasionally Mrs Driver would do some deliveries in her car, but she generally kept away from the school and farming aspects. Ex-pupils remember her 'zipping about' in her car, and her grandson recalls that she was a very fast driver well into her seventies. Her husband, despite the name, could not drive and had no wish to. He even disliked travelling by car and, according to his grandson, he had to be 'tranquillised' with a couple of stiff drinks before he would travel with his wife. This might have been because of her driving, but it is possible that he felt claustrophobic in a small car. He seemed happy enough on school outings by coach, though apparently on those trips he was well known for leading the singing and being the life and soul of the party on the way home. In fact, he had a horror of all things mechanical, which is surprising given his lifelong commitment to learning and progress. Mrs Driver, on the other hand, enjoyed tinkering with her car and using new gadgets, and their son must have taken after her, as he studied electrical engineering at university.

Throughout 1943 the assistant teacher, Mrs Jones, had several periods of illness and in December she left and was not replaced. This was the start of a lengthy period when Mr Driver and Miss Poole ran the school on their own. They were more than capable of achieving good results, but 1944 brought serious epidemics, primarily of whooping cough, which greatly reduced the attendance for several months. The Diocesan report that year states:

Very good, but not as good as usual. One is accustomed to expect an unusually high standard of attainment from the children of Maisemore School, but during the past year the work has been carried on under difficulties. The Staff has been reduced by one and the attendance is still affected by a widespread epidemic of whooping cough. Consequently it is only natural to find that the usual high level of attainment had not been reached. This however should not cause any despondency as one is confident that it is but a temporary setback and that once the children have recovered their normal health, the normal level of attainment will soon be reached.

Although Mr Driver may have been disappointed that the report was not as excellent as usual, it is reassuring that the inspectors were sensible and objective, and not blinded by the 'halo effect' to praise schools that regularly deserved praise.

In mid-1944 several evacuees arrived at the school. One child from Liverpool had attended briefly in 1942, but there had not been an influx of children as was the case in some neighbouring parishes. However, by 1944 the development of pilotless V-1 flying bombs and V-2 rockets had again brought serious threat to London and some children who had stayed in the capital (or had left and returned) were evacuated to the countryside. Eight children turned up from central London between July and September, but they all left again within two months or less, with the exception of three siblings, the Daleys from London's Docklands, who stayed until February 1945. It is hard to imagine what these city children made of rural Maisemore. Coping with pigs, poultry, bees and rabbits would have been totally alien to them. One of those was Norman Tice, who came with his brother from Paddington in August 1944. He did not see himself as a 'real' evacuee, as he stayed with the Charles family, who were friends of his parents, and in fact his parents came regularly to visit them as his father was in a reserved occupation. He recalls the time as a big adventure. What made the biggest impression on him was drawing water from the pump in the Charles' yard – and their toilet, which was twenty yards down the garden in a brick-built shed, a scary place in the dark. On the other hand, he does not remember much about the lessons in class, other than that he never got into trouble. He was, however, amazed by the fruit trees in the school grounds. He helped pick plums and apples, and fill bags with produce. He went to the local farms with the other schoolchildren, picking fruit and lifting potatoes. He also remembers going fishing with his friends and getting shouted at for running through the farmers' fields. He thoroughly enjoyed his time in the countryside. The war – and the city – seemed very far away.

Some building work took place at the school at this time. As a temporary wartime measure, the County Council decided that a 'wash-up' for school dinners should be erected. The school managers were a bit annoyed that they were not even consulted and were initially unsure who was to do the work. They were adamant that the teachers could not be expected to do this. They also worried about responsibility

for its upkeep. They had enough upkeep problems with the school building itself, in addition to the water situation, which remained difficult. Fortunately the vicar had managed to obtain the loan of a watercart that was filled and placed in the school yard, to be used for flushing the lavatories. Throughout 1944 arrangements were made for the opening of the school canteen and it was finally ready and served the first lunches to every pupil on the register on 9 February 1945. Of course, the school – along with the rest of Maisemore – was not connected to mains drainage, and therefore the dirty washing-up water was collected in a tank. Apparently, one of the local men used to empty it out regularly with a bucket into the nearest hedgerow.

A construction of a different kind was welcomed by the pupils: in March Mr Smith, the County Physical Instruction Advisor, erected an 'outdoor gymnasium' in the playground, according to the logbook. This sounds rather grand, but former pupils only remember a high bar that they could swing on.

Mr Smith had become a regular visitor and had suggested some innovations in exercises which were very popular with the pupils. After his early visits in 1938, the *Maisemorian* recorded, 'The new physical exercises have much more interesting movements and are graceful, rather than stiff and artificial.' The children were very fit and fortunate to be well fed in wartime. They continued to enjoy sport and always recorded the results of the annual Sports Days. In addition to the usual 100 and 200 yards race, long jump and high jump, there were events for the less athletic, such as hopping, three-legged hopping, throwing the ball and something called the Duck Race. By this time, the school had been divided into Houses and the pupils took pride in earning points or winning races for their House. The Houses were named after local personalities who had taken great interest in the school: Barnes, Cridlan, Stephens and Rudd. There were relay races in House teams involving all the pupils, and one set of results reads:

Running:	Stephens, Cridlan, Rudd
Hopping:	Rudd, Barnes, Stephens
Leapfrog:	Barnes, Stephens and Rudd, Cridlan
Catching:	Rudd, Cridlan, Barnes

Mr Driver was keen for all pupils to participate in some way and take pride in their House.

An extract from a wartime *Maisemorian* reflects the children's interest in sport:

We have greatly enjoyed our games and physical exercises this year, and they have certainly made us better in health. The boys show excellent form at football: L Banks, G Woodward, T Wadley and M Wadley deserving special mention.

In cricket the batting has considerably improved while the bowling is of a good length and accurate. Fielding as in the previous years is distinctly good. Our

Behind Mr and Mrs Driver in the playground is the high bar, the 'outdoor gymnasium'.

leading players are T Wadley, M Wadley, M Banks, G Woodward, N Adamson, R Dunn and V Woodward. We are grateful to Mr Chamberlayne for the use of his field.

Again this year the Championships produced a very keen competition. Congratulations to Stephens' House on their fourth success and to B Cole and M Wadley, the individual champions.

Inside the school, the academic life was back on track, even though there were only the two teachers. Reverend Gilpin, the Diocesan inspector, reported in 1945, 'This small school is worthy of high praise and I have no criticism to offer.' In May, the school and the country had the news they had been waiting for – VE Day. To mark this, the school closed for two days of celebration and there was a special church service conducted by the vicar. And of course, there were pupils' poems to mark the occasion. Optimism was in good supply in Maisemore, and as early as July 1944 one pupil, H. Barnes (no relation to Horace Barnes), had written:

> Hark! The bells are ringing, the sign of victory.
> We have started the Jerry running over land and sea.
> Now mothers, wives and sweethearts, be brave and do not sigh –
> You will see a silver lining very soon in the sky.
>
> Then when the boys come home again, how proud you all will be,
> To know your son or father has helped for Victory.
> Now all we at home can do is pray
> That God will send them home some day.

But in July 1945, it was the real thing and the following poem shows that the writer understood that life would never be the same again for the men who had served:

> **Victory** by A. Willis
>
> We have won one victory,
> Another is on the way.
> It's the Japs this time, and not the Hun
> Who'll wish this war they'd ne'er begun.
>
> Our men who fought, their lives were brave,
> They fought and fell our lives to save;
> They don't want medals, praise or fuss,
> They want to be free, like all of us.

When it is finished, we will have to begin
Raising our glasses full of good things,
To all our brave boys, our English men,
The men who will start life all over again.

Academic work continued to the usual high standard: pupils won places at grammar school, and the PNEU syllabus and library books provided plenty to read and enjoy. The pupils still took weather readings every day from the weather station set up in 1921. In the garden, work continued with the usual successful results. After their success in 1943, the pupils again won the Championship at the Gloucester Horticultural Show in 1944, and in 1945 they won thirteen Firsts, four Seconds, and one Third prize and the overall Championship. The BBC, which had visited in 1942, returned to discuss rural methods, and in August made a recording about the Rural Subjects teaching.

The pupils' capacity for fundraising was undiminished. In mid-November was Thanksgiving Week, and the school set itself the target of raising £2,000. They raised £6,505. In January 1946, all the children visited the pantomime in Cheltenham as part of their VJ treat. It is not clear whether this was funded locally or nationally, but in any event, the children or their parents did not pay.

Peacetime Brings
the Threat of Closure

Logbook entries are sketchy at this time, perhaps because Mr Driver was preoccupied with another matter. In 1945 the school managers recorded a strange episode in the school's history. The 1944 Education Act had guaranteed free secondary education for children up to the age of fifteen and decreed that children over eleven years of age should go to secondary schools. Gloucestershire County Council had studied the ruling, and circulated its draft Development Plan to local schools. In November 1945, the Maisemore school managers discussed the proposals, which seemed to suggest the amalgamation of some of the schools in the villages of Ashleworth, Corse, Staunton, Tirley and Maisemore. The managers agreed that, seeing that there appeared to be no alternative to the closing of Maisemore School, they would rather be linked with Hartpury, in preference to the parishes named in the County Education Office proposal. As there was to be a meeting of managers of schools named with Maisemore in the Development Plan, it was decided to defer Maisemore's comments until after that meeting. This took place at Ashleworth in January 1946, and in Maisemore's view the outcome was totally unsatisfactory. The managers therefore wrote to the County Education Office, stating their strong preference to merge with Hartpury. In due course the County Council responded, saying that this would be acceptable and that Hartpury School was willing to admit the Maisemore pupils. Continuing correspondence from the managers to the County stated that the managers agreed to the proposal, but Maisemore children would only travel to Hartpury if transport were provided for them. And then – nothing. The managers' reports do not mention the topic again, and Maisemore Church of England School continued to operate as normal.

One of the factors in the abortive plan to transfer the children to Hartpury was probably the poor state of repair of the school premises. While all the above debate was taking place, the building was assessed by an architect sent from the County

Council, and his findings were not encouraging. In 1946 the Diocesan inspector recorded that the teaching was excellent, 'but the floor of the school is bordering on being dangerous'. He added, 'The piano is quite the worst instrument that I have ever heard, not a single note being in tune. The result is that the singing is not what it well might be.' The school managers were aware, as always, of the problems, though they did not replace the piano. Mr Driver and Miss Poole soldiered on, but in the summer holidays the managers were able to arrange repairs to the floor, windows and stove, and thorough cleaning of the walls and whitewashing of the lavatories. By November 1946, even the school managers had to admit that the playground was in a deplorable condition. It was impossible for the boys to reach the porch and the doorway that was the main entrance to the school without at times being ankle deep in mud. Mr and Mrs Driver faced the same conditions each time they left or approached their house. The winter of 1946/47 was one of the coldest recorded in Gloucestershire, with snow drifts and icy weather for weeks, so it was not a good time for new building work.

Activities in and out of School Continue to Flourish

Inside the school, Mr Driver organised fundraising yet again for a new piano. The school managers found that, if they could raise half the cost, then the County Education Department would match it. They therefore authorised the purchase of a reconditioned piano for £52 10s, provided it was checked over first by the church organist, Mr Phipps. Fortunately Mr Phipps agreed that it was a good buy and the purchase went ahead. During the summer holidays in 1947 the school building and redecoration work was completed, and the piano was installed ready for the new school year on 9 September. However, numbers were already dwindling. But pupils still won scholarships to grammar or high schools, and the visitors continued to come to study method and/or rural subjects. On 5 December 1947, the logbook entry reads, 'The Rural Subjects were filmed today.' Whether this was for an early television programme is not clear, but at Speech Day (which that year was in December instead of the summer) the Honourable Mrs Bathurst presented the school with a wireless set, so that they could listen to the forthcoming BBC broadcast describing the school's rural activities. Also at that Speech Day was a former pupil who had left the previous year to go to Ribston Hall. As she was a gifted pianist, she was invited back by Mr Driver to give a recital to celebrate the new piano.

In 1948 Mr Driver's brother, Wilfred, came to visit from Australia and stayed for several months. During that time he taught the boys stoolball, which was previously unknown to them. Stoolball is an ancient Sussex game which was revived during the First World War by an army doctor who thought it would be a less strenuous form of sport than tennis or cricket for servicemen who had lost an arm or a leg. It

became very popular in the south of England and the game was played in Japan, France, Canada, Africa, Australia, and other countries. Some clubs still exist today in Sussex, Surrey and Kent. The original game, dating from the fifteenth century, was played by milkmaids, who would throw a ball at a milking stool suspended from a tree. It is sometimes called 'cricket in the air', as the ball is bowled, not as originally at a stool, but at a 'wicket' which is a square piece of wood at head or shoulder height fastened to a post. The 1917 updated rulebook says that the batsmen score runs by running between wickets placed 16 yards apart, but it is unlikely that such precise measurements were made at Maisemore. The bowlers bowl in overs, underhand, 10 yards from each wicket. The official bats look like long-handled table tennis bats, but the Maisemore pupils made do with whatever they used for rounders and other sports. The great advantage was that the game could be played with between four and eleven people in a team on any open space since the game does not require level ground, and Maisemore school playground was anything but level.

A regular visitor to the school was Mr Green, 'the bee man', who gave demonstrations on swarming and hiving and other aspects of bee care. Although all pupils took part in the lessons and learnt a bit about bee-keeping, some pupils took a much greater interest. Foremost among those were Leo and Leslie Hiam, sons of the local builders, who left the school at the age of thirteen well before the Second World War, and joined the family business. They used to come back in the evenings and at the weekend to help with the bees, as well as keeping hives of their own. During the war, the brothers went off to help the war effort, so had to leave their bees to their own devices, but on their return, they still had the enthusiasm and started bee-keeping again. Leo later said to his son that bee-keeping was not a hobby: it was a disease! The brothers put this 'affliction' to good use and went on to open Maisemore Apiaries in 1953. They obviously worked hard to establish the business, but their early training at school in taking responsibility and managing money and profit and loss must have stood them in good stead. Over the years they built up the business to the success it is today, still family-run by the third generation of Hiams, selling bee-keeping equipment worldwide from some of the same buildings that Leo and Leslie worked in, though there are now additional modern buildings and over 1,000 hives in the surrounding area. It is a notable example of the effect of Mr Driver's rural studies programme on the lives of pupils and the community.

The press continued to take a keen interest in activities at the school. In the time of post-war rationing, the growing of one's own food became of great interest to a wide section of the population. In Maisemore of course, it was not just school pupils who were involved, but the whole community, as so many villagers were members of the Pig and Poultry Club, still run successfully by Mr Driver. During the war, the club was affiliated to the Village Produce Association, which encouraged the growing of vegetables and the raising of animals for food. Maisemore's success was feted in

Wilfred and Alfred Driver on a day out in 1948, during Wilfred's visit from Australia.

Stoolball is still played, as shown in this photograph from a County Juniors match at Clayton, East Sussex, in July 2008.

Pupils in protective clothing with a bee smoker as they prepare to work on the hives.

the press as an example to inspire others. An article in a Birmingham newspaper in November 1947 made clear who was behind the success, even if the journalist did write that 'Mr Driver, 56, is not the kind of man you would look twice at in the street'. He went on to list the ways in which the Pig and Poultry Club had helped the village: the club bought seed potatoes by the ton, which meant that individual members could buy small amounts such as 28 lb at about half the usual price. The club also bought seeds and fertiliser in bulk, saving villagers up to £3 a year on their allotments, while local garden-tool shopkeepers offered discounts to club members, often as much as 10 per cent, and there were also the benefits of working together to manage a larger plot than was suitable for one person. That year, the eighty members had raised 70 pigs for bacon, 40,000 eggs, 10 tons of potatoes, 1½ tons of onions, 5 cwt of honey, and 3½ cwt of rabbit meat. By comparison, the school children had achieved the following: 12,000 eggs, 2 tons of potatoes, 2 cwt of poultry meat, 1 ton of bacon, 1 cwt of rabbit meat, half a cwt of honey and lots of other vegetables. And for all this, Mr Driver dealt with the wholesalers and retail food buyers, filled in the forms, handled the accounts and coped with the Ministry inspectors. No wonder that the article concludes, 'Every street in every suburb or town could use its own Mr Driver.'

The following year, the *Gloucester Journal* devoted a full page to the school under the title 'Maisemore gives a lead to the nation'. Once again it publicised the success of the Pig and Poultry Club, now apparently with ninety-five members, and highlighted the advantages of bulk buying. Women as well as men were involved in all the activities. In the summer, farm labourers worked long hours, and so the wives played a big part in the success of the club, regularly working in the allotments in the evenings. Mr Driver alone took care of the multiplicity of forms which had to be dealt with and organised the sale of surplus produce. That year Mr Driver had ordered and supplied to members over 11 tons of Scotch seed potatoes, 500 tomato plants, 2 tons of fertilisers and 20 collections of seeds.

As for the school, like everyone else who had seen the pupils at work, the journalist was charmed by the interest and dedication of the youngsters. He enjoyed seeing that year's chickens scratching about in the evening sunshine and was impressed that during the Christmas holidays two boys and a girl had looked after all the livestock, including eight pigs worth over £100. He noted with approval that 'self-reliance is engrained in the pupils', just as Mr Household had commented twenty years before.

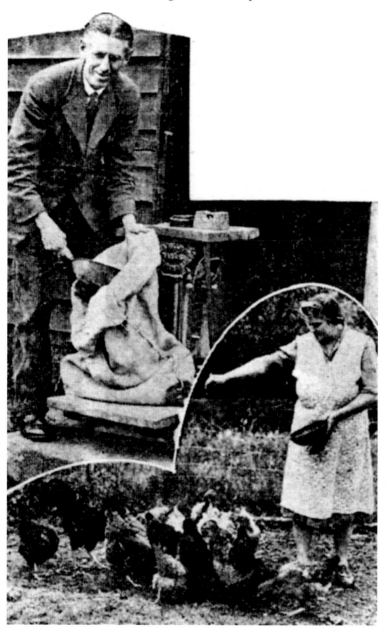

Mr Driver weighs out the supplies on his ancient scales, and a lady in the Pig and Poultry Club tends her chickens.

Work in the Community

As part of his strong involvement with the church, Mr Driver was secretary of the Maisemore Parochial Church Council and continued to sing in the church choir, as he had always done.

In addition to everything else, Mr Driver continued as a parish councillor. Once again, it seemed that every time something needed to be done, he was the one to do it. In 1946 a scheduled parish election during an influenza epidemic did not take place as the parish clerk had been unwell and did not advertise it. It fell to Mr Driver and Mr Chamberlayne to explain this oversight to the County Council. Shortly afterwards the election was held, and the votes cast underlined Mr Driver's pre-eminent position in the community:

Mr Driver – 34; Mr Chamberlayne – 25; Mr Bubb – 25; Mrs Buchanan – 22; Mr Probert – 22.

Mr Driver immediately proposed Mr Chamberlayne as chairman, and he himself became vice-chairman. Although it was then decided to appoint a paid parish clerk, until that person took up his post Mr Driver wrote any necessary correspondence.

In fact, even when there was a paid parish clerk, Mr Driver often dealt with the paperwork. For example, in 1947 a consignment of food was sent from South Africa to the UK to be distributed to the aged and the needy. Local councils were to supply the names of those eligible. Mr Driver and Mr Probert dealt with correspondence on the matter, although it was the chairman who was to be responsible for the distribution of the food gifts.

A subject close to Mr Driver's heart was the village hall, or lack thereof. The village had no venue for social events or meetings, other than the school. This was far from ideal and sometimes preparation for a concert, or clearing up afterwards, could disrupt school work. He raised the topic, not for the first time, at a parish council meeting in August that year, and said pointedly that he did not want to see the matter drop. He was told that it could be dealt with at the next meeting. His indefatigable determination to improve things for the community led to other efforts to secure street lighting in the parish, to arrange the installation of a telephone kiosk, and to improve the bus service to Gloucester. After letters were written to the Bristol Tramway & Carriage Company, additional buses were laid on, but not at times that people wanted to use them, and of course as they were not popular, they were withdrawn again. He did at least secure the publication of a timetable, as before then the bus driver left more or less when he felt like it. The vagaries of the bus service had previously prompted at least one poem (unsigned) that was recorded by Mr Driver:

Waiting for the Bus

Here we are – all five of us
Waiting for the Maisemore bus.
But suppose it never comes
And we fail to reach our home.

What an age we've had to wait.
Roy and Helen, Mum and Dad,
Dad looks cross, Mum is tired
Waiting for the Maisemore bus.

Roy and Helen are quite worn out.
Helen may fret, Roy may pout.
It's no use to make a fuss;
That won't bring the Maisemore bus.

Lots of other buses pass
But they are not ours, alas!
So we go on standing here
Hoping ours will soon appear.

There it is – our bus at last.
'Do be careful. Please hold fast'.
Yes! There's room for five of us
In the Maisemore bus.

Others in the village were not keen on street lighting, and the matter kept being postponed 'till the next meeting'. In March 1947 there were record floods in the village following the very severe winter. School meals could not reach the school for over a week, and many villagers had to leave their flooded homes. In the parish council, Mr Driver was quick to propose a vote of thanks to Mr and Mrs Chamberlayne and Mrs Buchanan, for all their work in helping flood victims. The local crisis pushed the street lighting and the village hall down the agenda for the time being, but at least Mr Driver was able to reassure the parish council that the school would remain open for at least another fifteen years, and it was therefore worthwhile asking the County for 'SCHOOL' warning signs on the nearby roads. (These were erected the following year.)

In 1948 Mr Driver tried again to push through a decision about a village hall. The £150 bond bought towards its cost was due for redemption, and the County Council gave permission for it to be reinvested. All were agreed that the village needed a village hall, but more than a few were willing to consider a temporary

structure if they could not have a permanent one. The Rural District Council said that it could possibly help with the cost of a change to a permanent structure in due course.

Mr Chamberlayne knew of a possible source of a temporary building, a Nissen hut (60 feet by 30 feet) from Ashchurch Camp. In March that year, a County representative explained a new scheme by Gloucestershire Community Council to help villages to obtain temporary village halls. The Community Council would grant loans towards the cost of land, which would remain their property, with the village paying rent. By then, the Maisemore Village Hall Fund stood at £367 17s 3d. There was much discussion about which way to proceed, but eventually the decision was to go ahead with the temporary village hall, preferably a scheme that could include a sports field. Mr Driver was not in favour, believing that if a temporary structure were used, it would still be in place fifty years later. (Once again, he was to be proved right, as the smart new Maisemore Village Hall was opened in October 1995.) His opposition may explain why he does not feature on the Village Hall Scheme Committee, which had five members: Mr Chamberlayne, Mr Bretherton, Mrs Buchanan, Mr David Charles and Mr Ted Bubb. Or it could be that Mr Driver did not have enough time. He did, however, move a motion that the names of those who lost their lives in the Second World War should be added to the existing war memorial, but that the war memorial proper be the village hall. This matter was left in the hands of the Village Hall Committee.

Mr Driver remained active on the parish council for the next few years, taking the lead on an approach to the Rural District Council about the water rate and attending meetings at Shire Hall with Mr Chamberlayne about the protection of 'open countryside in the Gloucestershire RDC'. He is listed as present at a parish council meeting in January 1952, but in the minutes of the March meeting, which record that all the members were present, he is not included in the list. It is quite feasible that he had decided to retire from the council, but there seems to have been no thanks or tribute recorded after all his years of service. Perhaps that was because he was always the one to propose the vote of thanks and appreciation for work done in the council, just as he always encouraged his pupils to thank others in the *Maisemorian*.

Although 1948 started badly for the school with a serious outbreak of measles in the first few months, the year improved: a holiday for the silver wedding anniversary of the King and Queen, school exhibits sent to the Three Counties Show, and the annual outing, that year to Weymouth, which was a lot farther than the usual trip. The continuing stream of visitors included a Dr Wattsteen of Zurich. In the summer holidays yet more work was done on the school interior at a cost of £101 18s, and the school managers were delighted later in the year when they were informed that the County Council could repair the playground if it was in a bad state. This was a great relief for everyone, and the playground was at last resurfaced in the spring of 1949. Another notable event that year was the presentation of the

Bathurst Shield to the school in recognition of its position as the leading school in the competition in each year that it was run, even though the rules meant that its name is only on the shield every third year. The shield was on display at the school until it closed in 1986, and since then has been kept in the village, where all still take considerable and justified pride in the achievement it represents.

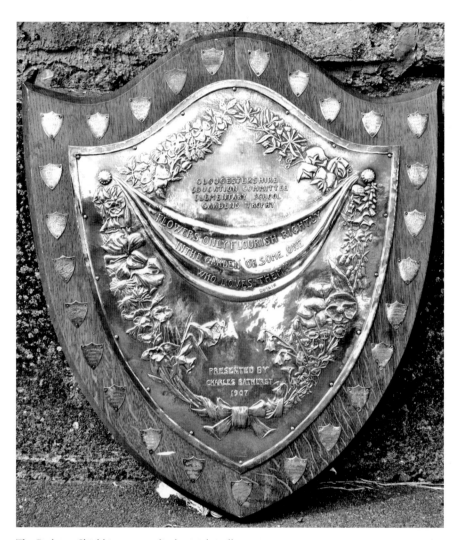

The Bathurst Shield is now on display in the village.

The Beginning of the End

By 1949, the times were changing. Gloucestershire had still not fully implemented the provisions of the 1944 Education Act regarding the transfer of pupils over eleven years of age to secondary schools. This was gradually being introduced throughout England, but Maisemore still had pupils up to the age of fourteen – and given its phenomenal success, there had been no urgent pressure for it to comply. The managers were first approached on the matter in July 1948 with the suggestion that the older pupils should move to Newent Picklenash School. The managers thought it acceptable for those over thirteen, but not from the age of eleven. But by October 1949, the HMI chief inspector asked Mr Driver to speak to the school managers about transferring children over eleven to Newent Secondary Modern School. Even though he realised that such a move would have a detrimental effect on his own school, Mr Driver readily agreed. He could see it was in the best interests of the pupils in the long term, as they would have access to foreign-language teaching and more advanced science and mathematics than he was able to offer. In any case, it was now the law. He was able to persuade the managers that the Maisemore children should go. Over twenty pupils therefore left in December 1949 and transferred to Newent, leaving thirty-one pupils of primary age at the school. As a result, the Rural Club at Maisemore School was officially closed, with a record bonus that year of £40. Nevertheless, the gardens, the pigs, the rabbits and the bees were still there.

The HMI inspectors were never far away, and in early 1950, one reported on the situation now that the older children had left. As ever, there was praise of Mr Driver and Miss Poole:

> There are at present 31 children of primary age, the older pupils having recently been transferred to other schools. The Head teacher has been in charge since 1915 and continues to carry out his duties in a highly satisfactory manner. He is

ably assisted by a mistress who has also given long and loyal service and whose personality and skill provide the children with a happy introduction to school life. The good features which have been noted in previous reports are being maintained. It will be interesting to see what educational use is made of the garden and the small livestock for the younger pupils.

In both classes full use is made of the children's interest and experiences. They behave in a natural and friendly manner and they talk freely with their teacher and with visitors. The various activities are well-planned, and the written exercises and the work in art show promise. The children obviously enjoy the prevailing atmosphere of freedom and purposeful effort. Some wireless lessons are included in the course.

The interior of the school has recently been decorated and all children take milk and midday meal at school. The playground now has a hard surface and the school is adequately equipped.

It was, in fact, a great relief to all that the playground at last had a hard surface, as in early 1950 there was serious flooding in the area. The inspector's report is all the more encouraging as he visited in the middle of a whooping cough epidemic that was serious enough to merit mention in the logbook. The County's growing attention to health and welfare was seen in the introduction in 1950 of an experimental hearing test carried out on the children by a Dr Sutcliff. There had been annual visits by the school dentist, and regular medical inspections, but this is the first hearing test recorded. Unfortunately, before Dr Sutcliff could complete his work, there was a serious influenza epidemic in the first part of 1951, which meant that the hearing survey was not completed until May. After that it became an annual event. One of the victims of the influenza epidemic was the school cleaner, Mrs O'Brien. She was absent for several weeks; during that time Mr Driver himself cleaned the school, and Mrs Driver ran the canteen until Mrs O'Brien's return. This is yet another example of the way Mr Driver did not waste time complaining about problems – he just got on with solving them.

And still the visitors came. At this time they included 'three District Officers from Africa', no doubt to observe the pigs methods and rural studies teaching. The school was still committed to the PNEU programme and continued to receive books and examination papers from Ambleside. As a mark of the school's success in the scheme, two pupils went to London on 25 September 1951 as part of the Gloucestershire contingent at the PNEU Jubilee gathering. They joined a large number of children from the many PNEU schools in the UK, as well as from home schoolrooms, in a service of thanksgiving at Church House, Dean's Yard, Westminster. This was led by the Bishop of St Albans, with contributions from Lady Brabourne and Lady Baden-Powell. The extent of the PNEU scheme was shown by the Diamond Jubilee magazine that included contributions from pupils all over the world – India, East Africa, South America, Canada, the Middle East – and also one from Terry Smith, aged 8½ from Maisemore:

Our pigs

My father has a little pig,
He also has a sow.
The sow had seven baby pigs
But they're gone to market now.

It's very hard to get the food
To feed the pigs these days;
We have to boil up roots and things
And find out other ways.

I love to watch the piggies eat,
They get in such a mess
With food all over head and ears,
And in their eyes, I guess.

And when they've finished up their food
Of roots both cooked and raw,
They gently get back to their bed
To lie down in the straw.

The Last Head Pig Boys

The ten-year-old boys who had been helping with the pigs found themselves in charge as the older boys had left, but they continued to look after the pigs to a very high standard. One of them, Brian Elkins, whose father had also been taught by Mr Driver, recalls those days with affection:

We boiled up the swill once a week in the cast-iron boiler or furnace and cooked it for about half a day. This was usually potatoes graded as unfit for human consumption, and marked with a purple dye. When the potatoes were being lifted, we used to go to the farms, and after the potato spinner had turned up the potatoes, we would 'scuffle' the bad or damaged ones for the pigs. When the swill was boiled, we put it through a mincer, then stored it in a big tank. We got to school by 8.30 every morning and cleaned out the pigs and fed them before lessons. We were allowed a bit of leeway to go to the pigsty at break or at lunchtime, and we were only too keen to continue our work there. Everything was always spotless.

The pigs at the school – at least in my time – were always saddlebacks [the black pigs with a white band, now classed as a rare breed]. Mr Driver would go

to the auctions and a farmer would help him choose some piglets. The piglets or 'stores' were kept for three to five months and fattened up until they were about 200 pound (ten score). But the pigs weren't killed on site – they were sent to the Hilliers Bacon Curing Company factory in Nailsworth. Sometimes this turned into a day out for the whole school, with prizes for 'guess the weight of the pig' which I always seemed to win! When the pigs left, the pens were always thoroughly cleaned and whitewashed and the wood creosoted.

The rabbits were similarly well cared for. Their hutches were creosoted every year. Of course to do that, we had to move the rabbits elsewhere, and on one occasion, the pig pens were conveniently empty. So I just popped the rabbits in there, all together, and never thought anything of it. But of course in next to no time after that, we had quite a lot of baby rabbits!

And we helped in the gardens as well – everyone did everything, and the Rural Club money was shared out, perhaps on a sliding scale, with the older ones who did more work getting more, but everyone got something.

There were about 200 chickens which the girls looked after, but during the summer holidays some of the boys would help load the egg lorry which called regularly. And don't forget the bees. I didn't do much with them, though the man who looked after the beehives at Maisemore Court came to show us things. I think he had a shop in Stroud Road, Gloucester. The bees liked the fruit trees, mainly eating apples, I think, which were all through the chicken runs and by the pigsties. The school yard was also full of beech and lime trees, so we had to play football in a field away from the school. We had a good football team. Mr Driver was very keen on that. The trees were all felled [in February 1949], but we still couldn't play football there, as it was full of felled trees for quite a long time.

The last tree to go was the 'Big Elm', a huge tree. There were no chainsaws in those days, and Brian remembers that the men cut all round the tree to angle its fall. Then chains were fixed round it and the timber wagon, proudly named 'The Woodland Queen', trundled down the field away from the school and eventually pulled it over. He also recalls that, no sooner was the playground cleared of trees than a big wooden caravan was parked there for a time. He believes this was something to do with a Church missionary, but there is no written record to confirm this. The playground was eventually resurfaced in May that year.

Brian still remembers the regular visitors – the Attendance Officer, Mr Bartlett, who always wore a trilby hat and looked very stern and forbidding; the 'nit' nurse, who came every week; and the dentist, who came once a year. Brian remembers having a tooth pulled out at school. He has happier memories of the Australian visitor, Mr Driver's brother, who brought seeds for them to plant and taught them stoolball. Brian enjoyed the game, but it does not seem to have caught on in Gloucestershire.

Brian Elkins also remembered time in the classroom. Like everyone else who attended the school, he commented on the temperature. In the infants' classroom, Miss Poole tended to stand right in front of the fire and hoist up her skirt to warm the backs of her legs, but this stopped the heat reaching anyone else. In the main classroom, the tortoise stove was still working away: 'You were fine at first if you were sat near the stove, but then you roasted. And if you were further away, you were frozen.' That wasn't the only daunting thing for a small child:

> I remember going up to the big room from the infants' classroom and thought that the room was full of adults. Some of the older boys of fourteen, or even fifteen, looked like grown men, but we were looked after. Boss Driver was very strict, so no one would mess about. He used to read us stories for about fifteen minutes every morning – *Treasure Island*, *Children of the New Forest*, *Pilgrim's Progress* and lots of others. He was such a good reader that he brought everything to life, and we would sit spellbound.
>
> We sometimes entered painting or writing competitions, national and local – we often didn't know which at the time. I remember winning a prize of £2 for a painting of a tea leaf, or rather a leaf from a tea bush, that was judged on the drawing and the quality of the handwriting on the caption. I was as pleased as punch. I think it was good to enter competitions. We were in a rural area, a bit cut off in some ways, and entering competitions along with children from other parts of the country kept us in touch with the rest of the world.
>
> We had a good education. We used to say if you didn't know something, Boss Driver would drive it into you. He set us up for life, really.

Brian recalled that Mr Driver continued to be very active in the community in the Pig and Poultry Club. He had started the club in 1916 and was still doing all the bulk buying and form-filling himself. Like most of the villagers, Brian's father ordered seed potatoes as part of the bulk order and would go to the schoolhouse to collect them from Mr Driver, who would weigh them out for each person.

Brian confirmed that Mrs Driver did not get involved in school activities, but helped in village events as a member of the Women's Institute. The pupils saw her frequently, getting into her Singer car or walking the dog. A school photograph of that time shows the children in front of the Drivers' garage and to one side is the garage end panel which was knocked out when Mrs Driver drove straight through it, much to the delight of the pupils.

In 1951, Brian Elkins won a place at grammar school, the Crypt School in Gloucester. Four pupils won scholarships that year. As the total roll number was now only twenty-nine, it is likely that these four were the only eleven-year-olds in the school. But their departure meant the end of the line for much of the farming

The children pose in front of the garage with its end panel missing.

endeavour. Although Ken Cole took over as Head Pig Boy, and he and others did an excellent job for several months, there were now too few pupils, and none older than eleven, to do all the work involved. Some of the pigs were sent to the Ministry of Food in June, and the last four went in December, achieving '36 score lb of bacon for the nation's larder'.

The Final Years

It was indeed the end of an era. The much-loved infants' teacher Lottie Poole retired on 21 December 1951, after forty years' loyal service to the school. She had been responsible for establishing a good foundation for the education of generations of children. In 1950, the HMI inspector had praised her ability and the warmth of her personality which had given so many children a 'happy introduction to school life'. Even in the last inspection of her career in 1951, the HMI and Diocesan reports noted that the infants were a model class. Her replacement was Mary Price, a qualified infants' teacher, who had only planned to stay at the school for the year, but in fact remained at the managers' request until May 1953.

Mr Driver made few logbook entries throughout 1952. He was not in the habit of recording routine events, and there were no further gardening and livestock successes to note. The whole school did, however, follow the funeral of King George VI on 15 February on the radio which had been provided by the Honourable Mrs Bathurst in 1947. The school trip was to Cheddar and Weston-super-Mare and two girls won scholarships. In September there is a rare reference to the weather, a mainstay of many school logbooks: apparently fires were lit in the infants' room, due to the very low temperatures. The savings movement that Mr Driver had started in 1916 was still going strong and, in the course of his time at Maisemore, it achieved savings of over £40,000.

On 19 December, Mr Driver records, 'An intelligence test was held – eight children sat.' There has been no previous mention of intelligence tests, but it may be relevant that in March the following year, seven pupils sat the entrance exam for grammar school. The IQ test may have determined the most suitable candidates. Ex-pupils all agree that they cannot remember any scholarship candidate being unsuccessful in the exams, so it is likely that Mr Driver assessed pupils himself either formally or informally before putting them forward for examination.

Miss Poole joins Mr Driver for the last time for a school photograph, 1951.

Although there was a serious epidemic of flu, followed by chickenpox in early 1953, the seven eleven-year-olds were well enough to sit the entrance exam for grammar school in March. It was the year of the Queen's coronation, and the pupils enjoyed extra holidays to celebrate and were treated to the film *A Queen Is Crowned* by a benefactor. The annual school outing was to Bristol Zoo and Weston-super-Mare. And still there were visitors to study teaching methods, with the last visits recorded on 3 July.

On 24 July 1953, Alfred Edgar Driver MBE retired. He wrote in the logbook, 'This being my last day as head teacher, I should like to express my appreciation for the support given me by the Education Committee, Inspectors and managers during my 38 years of office.' And his final entry showed the continuing pride in the pupils and school he had served for so long:

> Seven pupils have been successful in gaining places at Grammar Schools – Wendy Herbert, Mary Davies, Louise Sparrow, R. J. Gough, F. Cherington, C. Smith and L. Davies.

So ended a career of spectacular success, judged by the results: almost 100 children had won academic scholarships to grammar school; all the pupils had learned about gardening and animal rearing, which had led more than a few to satisfying and secure careers in agriculture and livestock; they had been given a strong moral foundation in the example of their teacher; and above all, they had learned to think for themselves and take responsibility. And in all this, Mr Driver had won the loyalty and respect of all the pupils. Gordon Hale (who won the scholarship to

Rendcomb in 1939) expresses the sentiments echoed by many former pupils when he recalls:

> Maisemore School was unique and for that Boss Driver was solely responsible. He was a remarkable man whose ideas regarding education were revolutionary and practised for many years. I remember having been very happy there and having learned a great deal about gardening and animal husbandry, much of which I continued to put to good use in later years. I shall never forget my time at the school or its remarkable headmaster. It was an honour to have known him and to have been taught by him.

On 19 September 1953 there was a special presentation to Mr Driver, when a large number of parents, old scholars and friends came 'to pay tribute in recognition of the faithful and devoted service which Mr Driver so readily gave to all who sought his advice'. Though always a quiet and unassuming man, he was no doubt delighted by a poem written in 1949 by Colin Jefferies, who was leaving to go to Tewkesbury Grammar School. Colin was the son of the local policeman and lived in Hartpury, where his father was based, but his was one of several families who lived outside the village – in Hartpury or Ashleworth – yet sent their children to school in Maisemore as it had such a good reputation. Colin's poem pays a final tribute to Mr Driver, in the words of a pupil, which is no doubt as he would have wished:

Farewell

I've so enjoyed my schooldays here
I hate to say goodbye.
Now time for leaving's drawing near
I can't restrain a sigh!

For thanks to Mr Driver's care
My Scholarship I've won.
I'm glad of course – but I'm aware
My good time here is done.

I don't know what I've liked the best
In sunny school time day:–
The lessons full of interest
Or jolly hours of play.

I know I've not been always good,
But not, I hope, too bad.

Farewell.

I've so enjoyed my School days here
I hate to say goodbye!
Now time for leaving's drawing near
I can't restrain a sigh!

For thanks to Mr. Driver's care
My Scholarship I've won.
I'm glad of course — but I'm aware
My good time here is done.

I don't know what I've liked the best
In sunny School time day:-
The lessons full of interest
Or jolly hours of play.

I know I've not been always good,
But not! I hope too bad!
I've learnt a lot — but so I should
Who such a Master had.

I'm sure that as through life I go
In climate hot or cool;
I'll ne'er forget the debt I owe
To days at Mansemore School.

C. Jefferies.
July. 1949.

This poem, copied out by Mr Driver himself, is the final entry in his book of collected poems.

I've learnt a lot – but so I should
Who such a master had.

I'm sure that as through life I go
In climates hot or cool,
I'll ne'er forget the debt I owe
To days at Maisemore School.

There are many over the years who would echo that sentiment and would never forget the debt they owe to Mr Driver who was, in the words of Horace Household, 'an altogether exceptional man'.

Postscript

The new headmistress was Mary Price, who had very recently been the infants' teacher. The school continued to function successfully, but she was no Mr Driver. She had to concede that he was a hard act to follow. She did not continue with the livestock or the gardening, or indeed most of the sport – Mr Driver himself had provided the annual medals and cups awarded at Sports Day, and after his retirement he sent them to the last pupil to win them. Miss Price devoted herself more to the academic work inside the classroom, where she continued using the PNEU scheme for some years. The pupils received a satisfactory education, but it became the norm for pupils to transfer to Newent Secondary Modern School rather than sit the grammar school (11-plus) exams. In 1959 Miss Price organised a very successful centenary celebration to which Mr and Mrs Driver and Miss Poole were invited.

The fabric of the school continued to be a cause of concern: despite a new grate in the infants' room, the temperature at 9 a.m. on 23 February 1955 was recorded at 43 °F. Pupil numbers declined, but the villagers fought successfully against closure in the 1960s, which had been proposed following the severe winter of 1963 when the big freeze meant no water for the outside lavatories. By 1986, however, they had to admit defeat, and Maisemore Church of England School closed, with the remaining handful of pupils transferring to Hartpury Primary School.

Mr and Mrs Driver moved away from the village when he retired and settled in Minchinhampton, close to Mrs Driver's sister. He did not become the lynchpin of the community as he had been at Maisemore and missed the activity and interest of his life's work, but he kept in close contact with many in the village who came to visit him. He did, however, dote on his only grandson, Dean, phoning or writing to him twice a week. Dean used to visit for several weeks at a time in the holidays and was devoted to his grandfather. So, in later life, Mr Driver enjoyed the sense of

Mr Driver attends the centenary celebration and chats to old friends and ex-pupils.

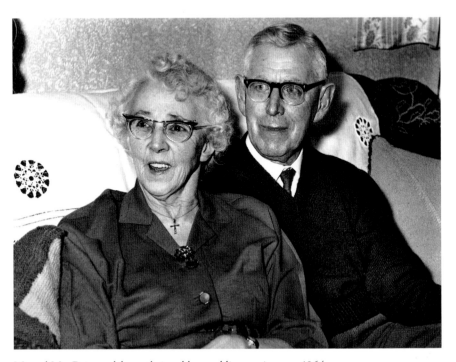

Mr and Mrs Driver celebrate their golden wedding anniversary, 1964.

family life that he had not had time to experience when his own son was growing up.

The couple celebrated their golden wedding anniversary in 1964, but Mr Driver's health was not good and he had to take a wide range of medication daily. On 17 July 1972, Alfred Edgar Driver MBE died of kidney failure. Although he had left the school and the village almost twenty years earlier, he was not forgotten, and in a final tribute, almost all the residents of Maisemore joined the funeral procession to pay their respects to a man who had quietly shaped all their lives.

Acknowledgements

I would like to thank the many people connected with Maisemore who have helped so much in the preparation of this book. They have been very welcoming and open to my questions, often supplying precious personal photographs, especially Beaty Banks, Val Chamberlayne, Betty Chamberlayne, Betty Cole, Ken Cole, Dean Driver, Brian Elkins, Carole Elkins, R. Gordon Hale, Tom Hathaway, Eric Hiam, Doreen Maidstone, Barbara Nelmes, Eric Probert, Enid Taylor and Norman Tice.

My thanks also to my friends at Gloucestershire Archives, who have been very encouraging and supportive, answering my endless questions with patience and good nature.

My thanks to Gloucestershire County Council and the Diocese of Gloucester, who have given me permission to quote from the following material held at Gloucestershire Archives: extracts from Horace Household's diaries, archive ref. AE/R5/36, 42, 49 and 52; extracts from Maisemore School logbook, archive ref. S210/1; extracts from the Bathurst Shield reports, archive ref. S210/10 and S210/1.

All extracts from HMI inspection reports remain Crown copyright, quoted under licence.

Extracts and sketch map from *A Maisemore Lad* by Gilbert Probert, by kind permission of Eric Probert (copy in Gloucestershire Archives, ref. GD144).

The children's poems are reprinted with the permission of the authors or their families, apart from three whom I have been unable to trace.

Copyright photographs from *Gloucester Journal*, 3 July 1948, by kind permission of Gloucestershire Media Group.

Photographs (1940) courtesy of Press Association Images.

Photograph of Wilfred and Alfred Driver by kind permission of Jeanette Driver and Roy Mitchell.

My thanks to Dean Driver for the use of some family photographs.

Stoolball photograph by kind permission of Brett Butler.

For further information about Charlotte Mason and the PNEU, see www.amblesideonline.org

And a final thanks to my family and close friends who have put up with my boundless enthusiasm for this project, particularly my husband who has helped me with the photographs and been generally supportive, and to Robert Drew of Amberley Publishing whose support and guidance have been invaluable.

Index

Page references in italics indicate illustrations